IMAGES
of America

OKLAHOMA CITY
STATEHOOD TO 1930

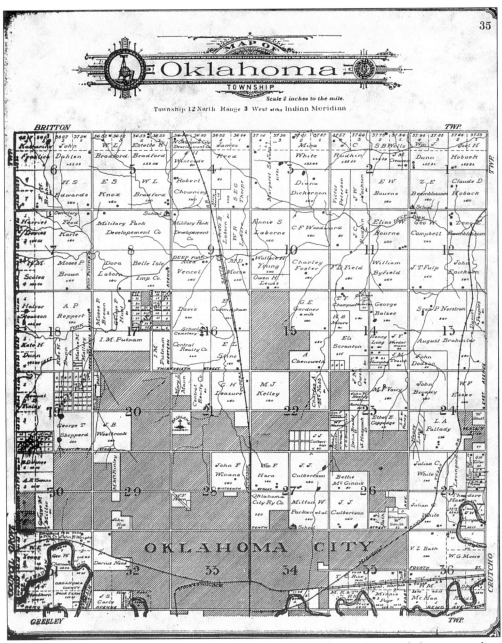

OKLAHOMA CITY, 1907. This plat map shows North Oklahoma City and the surrounding areas. (Griffith Archives.)

IMAGES
of America

OKLAHOMA CITY
STATEHOOD TO 1930

Terry L. Griffith

ARCADIA

Published by Arcadia Publishing,
an imprint of Tempus Publishing, Inc.
2 Cumberland Street
Charleston, SC 29401

Printed in Great Britain.

Library of Congress Catalog Card Number: 99-066665

For all general information contact Arcadia Publishing at:
Telephone 843-853-2070
Fax 843-853-0044
E-Mail arcadia@charleston.net

For customer service and orders:
Toll-Free 1-888-313-BOOK

Visit us on the internet at http://www.arcadiaimages.com

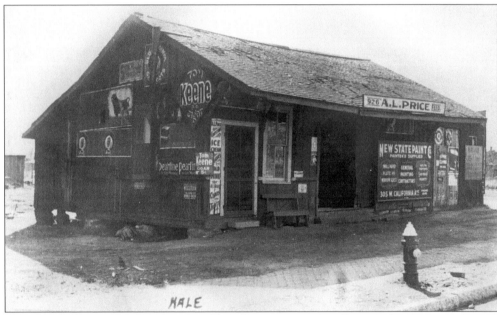

HAY, FEED, AND SEED DEALER. The old Wells Fargo Express office stands as a testament to a bygone era. The building has since become a billboard for various advertisers. When this photograph was taken by George Hale around 1911, the building was being rented from Frank Harrah to A. Lincoln Price, who changed his feed store locations throughout the city. By 1913, Price had relocated to 926 West Main. (Frank Harrah Collection of the Archives and Manuscripts Division of OHS.)*

* is used throughout the book to denote photographs that have never been seen in print before.

4

CONTENTS

SOURCES

Able, Charles F. *The Central Theme. A History of Central High School, 1892-1968.* Oklahoma City: Able Concepts Inc., 1985.

Blackburn, Bob L. *Heart of the Promised Land. Oklahoma County, An Illustrated History.* Woodland Hills, California: Windsor Publications, Inc., 1982.

_____. Arn Henderson, Melvena Thurman. *The Physical Legacy. Buildings of Oklahoma County, 1889-1931.* Oklahoma City: Southwestern Heritage Press, n.d.

_____. Paul Strasbaugh. *A History of the State Fair of Oklahoma.* Oklahoma City: Western Heritage Books, 1994.

Colcord, Charles Francis. *The Autobiography of Charles Francis Colcord, 1859-1954.* Tulsa: n.p., 1970.

Edwards, Jim. Hal Ottaway. *The Vanished Splendor.* Oklahoma City: Abalache Book Shop Publishing Co., 1982.

Mesta, Perle Skirvin, My Story. McGraw-Hill, New York. 1960.

_____. *The Vanished Splendor II.* Oklahoma City: Abalache Book Shop Publishing Co., 1983.

_____. Mitchell Oliphant. *The Vanished Splendor III.* Oklahoma City: Abalache Book Shop Publishing Co., 1985.

The Confederation of American Indians, comp. *Indian Reservations: A State and Federal Handbook.* Jefferson, North Carolina: McFarland & Co. Inc., 1974.

Welsh, Carol Holderby. "Cattle Market for the World. The Oklahoma National Stockyards." *The Chronicles of Oklahoma,* Vol. LX, 1982.

ACKNOWLEDGMENTS

While this second book is a continuation of the first, I realized that I failed to thank a few individuals who have helped me through their encouragement or guidance with their knowledge of Oklahoma City history: Dr. Bob Blackburn, Executive Director of the Oklahoma Historical Society; Ernest and Joy Ansley; and authors Jim Edwards, Mitchell Oliphant, and Hal Ottaway. For their stories of the city, I thank Lucyl Shirk, Phil Daugherty, Capt. Charles Coley, and Dr. Joe Coley.

A special thanks goes to my editor Jeffrey J. Lutonsky, and to Linda Kirkpatrick for proofreading the many pages of text. For getting the many photos ready, Ken Corder of the Oklahoma Department of Transportation; Chester Cowen at OHS; and for help in photograph identification, Streeter B. Flynn, Jr., Don Boulton, and Professor Yoko Sato.

And finally, my deepest appreciation goes my friend, Melvin Caraway—and ditto for my family, Glen and Mary Dustman, C.M. and Judy Griffith, and Quinton and Ann Hindman.

This book is dedicated to my grandparents Charles Brooks and Velva Griffith
May Their Memory Be Eternal

And also
Floyd "Hawk" and Audra Dustman
Thanks for everything

INTRODUCTION

The first session of the 59th Congress introduced the consideration of the statehood bill. The House of Representatives passed the Omnibus Statehood Bill providing for the admission of two states, one to be composed of the Indian and Oklahoma Territories and the other formed by uniting Arizona and New Mexico Territories. The Senate passed a bill that provided for the admission of Oklahoma and Indian Territory as one state. The question of single statehood for Arizona and New Mexico was left to a vote of the citizens of those territories, and a compromise was finally reached on all issues. Thus amended, the Omnibus Statehood Bill passed both the House and the Senate and became law June 14, 1906.

In Guthrie, Indian Territory, the Constitution and the Prohibition Ordinance were adopted in the general election of September 17, 1907. The saloons had until 11:50 p.m. the night of November 16th to close. Bartenders placed signs in their windows announcing "all goods sold at cost." A wholesale liquor sign on California Avenue had the corner on sales: "all going at $1.00 a quart." On the morning of November 16, 1907, more than ten thousand residents from Oklahoma City traveled to Guthrie to celebrate the recently won status of statehood. Monday morning, November 18th opened a saloon-less city. Overnight, 560 territorial saloons, 70 in Oklahoma City—with a yearly income of $3.7 million and three thousand employees—closed. Many opened, however, to "all sell soft drinks," among them the Two Johns next door to city hall. For the first time in the history of Oklahoma City, no drunks appeared in police court on Monday morning. Tuesday, however, County Judge Sam Hooker charged a man of "giving a drink of liquor," and was fined 50 dollars and 30 days in jail.

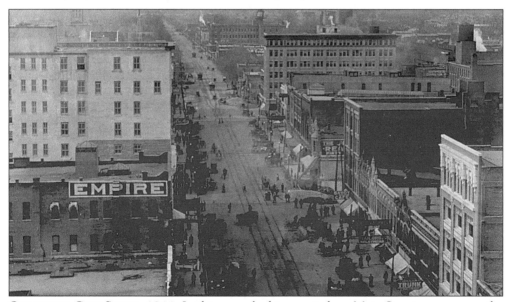

OKLAHOMA CITY SCENE, 1911. In this scene looking west along Main Street, one can see the tower of the old courthouse on the left. Choctaw Flour is being made in the mills on First and Francis to the right. (Griffith Archives.)

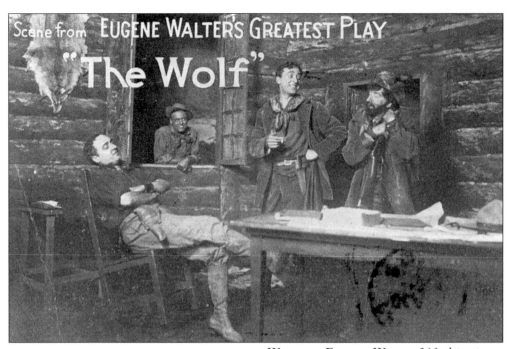

Scene from EUGENE WALTER'S GREATEST PLAY "The Wolf"

WHO WAS EUGENE WALTER? Nothing is known of Eugene Walter except for this promotional postcard, which was mailed out to area residents announcing the opening of "The Wolf," on Friday, October 15, 1909, at the Overholser Opera House. The back of this card informed patrons to "watch the daily papers for dates and tell your friends." The Overholser was in its 19th year of bringing quality plays to Oklahoma City. (Streeter B. Flynn, Jr., Collection.)*

FOURTH OF JULY, 1908. The old Street and Reed Undertaking Building was transformed into a patriotic showcase for a Fourth of July Parade. The marquee on the building at 214-216 West Main identifies the current occupants as the B&M Clothing Company; on the right at 218 is the Auora Bargin Store. The Colcord Building is visible in the background. (Kathleen Mauck Collection of the Archives and Manuscripts Division of OHS.)*

One

PACKINGTOWN

In 1908, Chamber of Commerce President Sidney L. Brock sent letters to northern and eastern meat packing companies giving them statistical information on Oklahoma City's climate, population growth, and potential market area. Thomas E. Wilson, executive vice-president of Morris & Company of Chicago, then came to look at possible sites for a packing plant in Oklahoma City. After a meeting with business leaders Anton Classen, John Shartel, George Stone, and E.K. Gaylord, Wilson was convinced that Oklahoma City would satisfy his company's requests. Wilson set forth several conditions: Morris & Company was to be paid $300,000 as an inducement; the stock yards area would be exempt from taxes for five years, sewer conditions would be extended to the plant area so that the plant's waste could be carried to the North Canadian river bed, streetcar lines were to be extended to the plant, and a railroad belt line was to connect with the four trunk lines in existence.

Chamber Vice-President George Stone helped Brock secure options on 575 acres of land in the area selected by Wilson, and Brock used $25,000 of his own money to purchase options on this land. Several days of festivities connected with Packingtown's opening, beginning with the arrival from Chicago of Morris, Wilson, and their wives. On October 1, 1910, 15,000 people visited Packingtown. As an adjunct to the packing plants, the Morris Company organized the Oklahoma National Stock Yards Company.

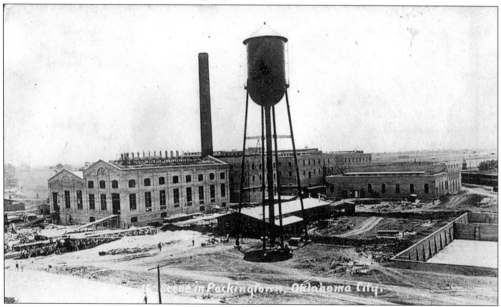

BIG PROMOTER. The *Daily Oklahoman* reported on October 8, 1910, that the Morris Company advertised for 15 businesses to locate in Packingtown. Included in this list were requests for a hay market, a harness factory, and "all sorts of stores." This postcard shows the Morris plant under construction. (Griffith Archives.)

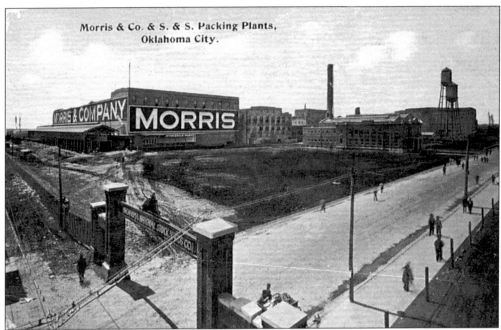

Morris & Co. & S. & S. Packing Plants, Oklahoma City.

FINISHED PLANT. Sidney L. Brock predicted that this multi-million dollar venture, the largest and most modern livestock enterprise ever constructed at one time, would benefit many industries. Land values in central Oklahoma had increased from $10 to $25 dollars per acre. These packing plants became Oklahoma City's largest employer and remained so for many years. (Griffith Archives.)

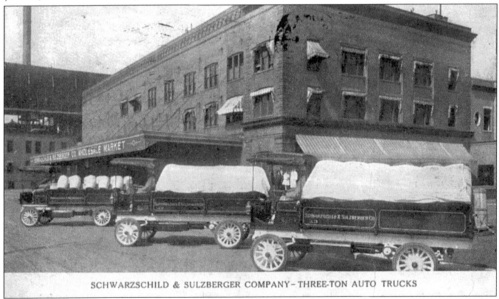

SCHWARZSCHILD & SULZBERGER COMPANY–THREE-TON AUTO TRUCKS

S & S COMPANY. Three months later, the Chamber received another proposal from Schwarzchild & Sulzberger Packing Company, demanding similar concessions that were given to the Morris Company. They asked for a $300,000 bonus, water, sewer, and gas extensions to the building site, a fire station and 350,000 gallons of free water daily for five years. This postcard shows the company's three-ton trucks. (Griffith Archives.)

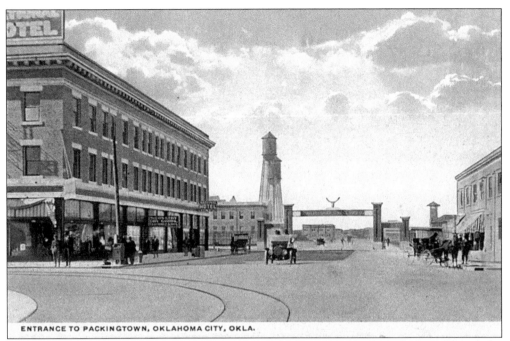

ENTRANCE TO PACKINGTOWN, OKLAHOMA CITY, OKLA.

LANDMARK GATES. The archway leading into the Oklahoma National Stock Yards features the famous steer's head watching over all who enter. The purpose of the stock yards was to provide an outlet for buying and selling livestock at prices based on supply and demand. (Griffith Archives.)

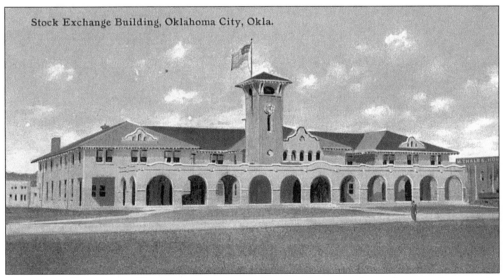

Stock Exchange Building, Oklahoma City, Okla.

LIVESTOCK EXCHANGE BUILDING. An integral part of the stock yards operation was its commission firms. When animals arrived at the yards, their owner turned them over to the chosen commission firm, which then was responsible for the livestock until they were sold. Although the commission rented offices from the Stock Yards Company, the firms were not charged for use of the pens. There were 17 commission firms operating at the yards when it started in 1910. (Griffith Archives.)

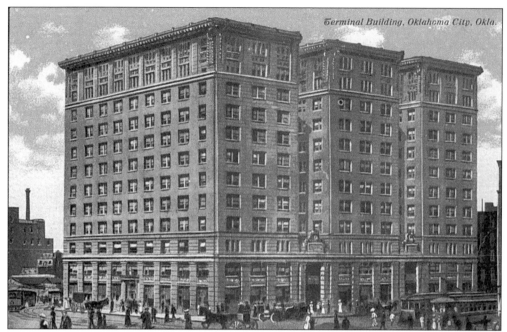

THE TERMINAL BUILDING. The large passenger and freight terminal located on West Grand was the Oklahoma Railway Company's main meeting point. (Griffith Archives.)

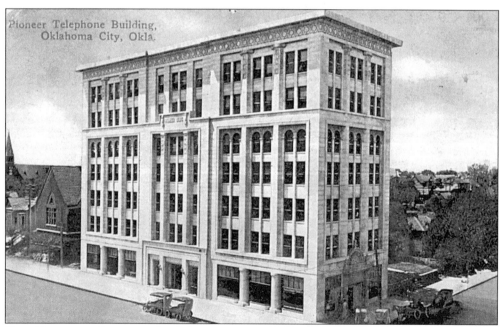

THE PIONEER. Constructed of limestone in 1907, this seven-story building was the headquarters of the Pioneer Telephone Company. This was the first Sullivanesque office building in Oklahoma City. The Pioneer remained in the building until 1916 when the firm merged with the Bell Telephone System. (Griffith Archives.)

Two

THE ARCHITECTS

Of all the architects that have shaped the skyline of the central business district, none have added more than S.A. (Sol) Layton and W.A. Wells. Sol was born in 1864 in Red Oak, Iowa. He moved to Wyoming with a partner in 1886 and then relocated to Colorado. In 1907, Layton opened an architectural office in Oklahoma City where he lived until his death in 1943. In his various partnerships, Layton was responsible for the design of more than one hundred buildings. He was involved in the concept and design of six hundred commercial structures in the downtown area, including the Baum, Patterson, Mercantile, Braniff, Medical Arts, Skirvin Hotel, and the Oklahoman Building. While he was with partner J.W. Hawk, he constructed the Workman residence in the Linwood Addition.

From 1904 to 1914, William A. Wells resided in Oklahoma City and practiced architecture. Influenced greatly by Louis H. Sullivan, Wells designed several public buildings in the downtown area, as well as numerous residential dwellings. The first structure, designed with partner George Burlinghof, was the Oklahoma County Courthouse, which was razed in 1950. He also designed the old Sears & Roebuck Building, the Carnegie Library, the Terminal Building, and the second and third homes to the Oklahoma City Golf and Country Club, all now gone. Two of his structures remain in the central business district, the Pioneer Telephone and the Colcord Buildings, both designed with the help of partner Arthur J. Williams.

The firm of Hawk & Parr has changed the architectural shape of downtown since 1905, when James Watson Hawk arrived in Oklahoma City. Josepheus O. Parr moved to Oklahoma City in 1911 and formed a partnership with Hawk in 1914 that continued until Hawk's retirement in 1932. Parr practiced until his death in 1940. The Hawk & Parr firm was responsible for many of the downtown buildings. Those that have not survived are the Biltmore Hotel, the Oklahoma Club, Commerce Exchange Building, and the Farmers National Bank. Examples of their work remain, and include the Tradesman's National Bank (built in 1921), the Harbour-Longmier Building (1925), and the Perrine Building (1927). The firm built many private homes as well, such as the 20,000 square-foot home of William T. Hales located at 1240 North Hudson.

THE COLCORD. In 1905, Charles Francis Colcord and Bob Galbrath purchased six lots on the corner of Grand and Robinson from Henry Overholser. Colcord wanted to build an office building while Galbrath wanted a hotel. With neither man giving in, Colcord bought out Galbrath's interest for $15,000, and built the first skyscraper of reinforced concrete in the city. He refused to build with steel, taking a lesson from the great fire of San Francisco. The cement used was hauled in from a rock quarry at Lost City, Indian Territory, at 25 cents a barrel. The builders began construction in 1909 and finished in 1910. Because this method was so risky, no bonding company would underwrite the construction. (Griffith Archives.)

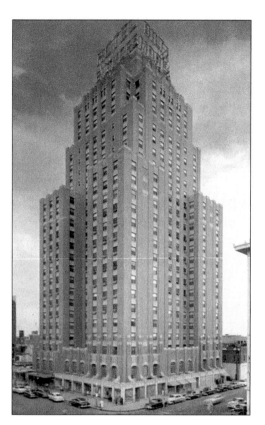

THE BILTMORE. Without a doubt, this was one of the finest hotels in the post-oil boom days of Oklahoma City. There were 619 rooms, each offering free radio, circulating ice water, ceiling fans, and later, air conditioning. (Griffith Archives.)

OKLAHOMA CLUB, 1921. The Oklahoma Club Building was seven stories high with a light red brick veneer, white stone trim, and a red tile roof. In 1922, the club welcomed members into the spacious ground floor lounge. The club's main dining room was on the second floor, and the members' wives and daughters enjoyed a ladies parlor and five private dining rooms on the third floor. The fourth, fifth, and sixth floors had apartments for members and their out-of-town guests. The seventh floor had a large ballroom, available for members and outside organizations. The club was built on the site of the old Grand Avenue Hotel. Today the site is a part of the Myriad Gardens. (Griffith Archives.)

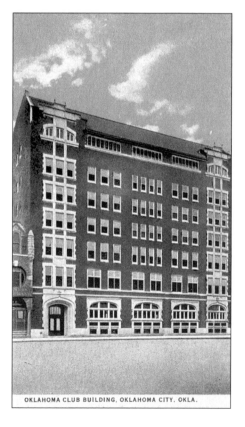

OKLAHOMA CLUB BUILDING, OKLAHOMA CITY, OKLA.

14

COMMERCE EXCHANGE. Located on the southeast corner of Grand and Robinson Avenues, the Commerce Exchange Building was built on the site of the first Overholser Opera House, built by Henry Overholser in 1890. (Griffith Archives.)

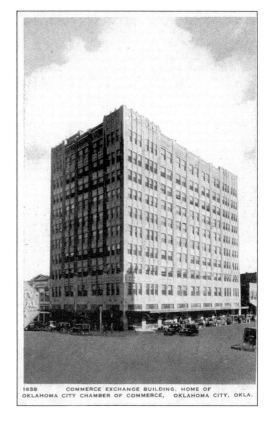

1658 COMMERCE EXCHANGE BUILDING, HOME OF
OKLAHOMA CITY CHAMBER OF COMMERCE, OKLAHOMA CITY, OKLA.

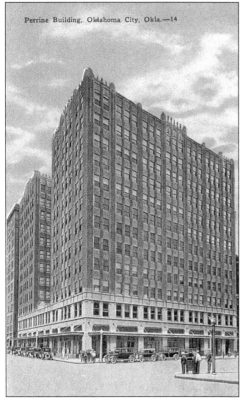

Perrine Building, Oklahoma City, Okla.—14

THE PERRINE. Built on the southwest corner of Robinson and Park, the Perrine opened for occupancy in 1927. Later renamed the Cravens Building, and then the First Life Assurance Building, it is known today as the Renaissance Building. (Griffith Archives.)

15

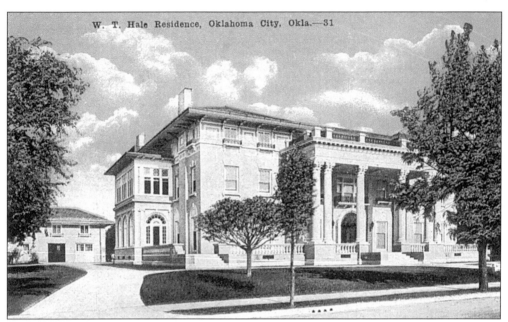

HALES MANSION. The building materials for this impressive residence were imported from Greece. After Hales passed away in 1939, the home was sold to the Roman Catholic Diocese of Oklahoma as the residence of the Bishop. Today the home is a private residence. (Griffith Archives.)

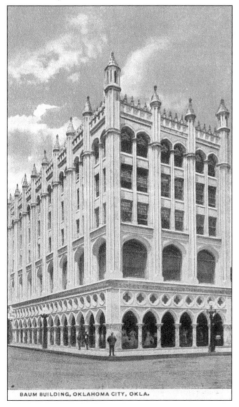

BAUM BUILDING, OKLAHOMA CITY, OKLA.

VENICE'S PALACE OF THE DOGE. In 1910, brothers Marx and Mose Baum constructed this building in the Italian style at a cost of $150,000. Located on the northeast corner of Grand and Robinson, the building was inspired by the Palace of the Doge, with its vaulted ceiling, arches, towers, and marble veneer. The Baum building became a victim of urban renewal. (Griffith Archives.)

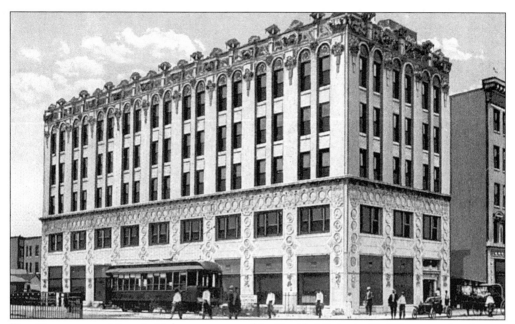

THE PATTERSON. Mary Jo Nelson was quoted in *Vanished Splendor II*, "The crowning feature was the twelve Corinthian baroque lighting fixtures spaced along the top cornice. Each one held a huge opaque lead glass light globe." The building was the last home to Kerr's Department Store. (Griffith Archives.)

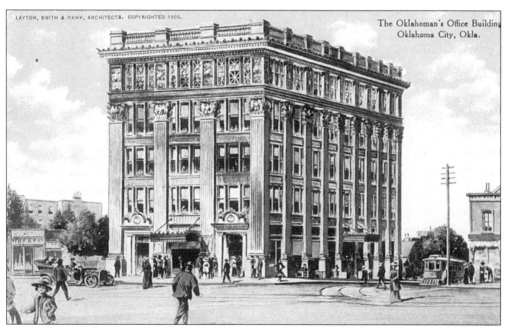

THE OKLAHOMAN. Beginning in 1889, Samuel Small founded what would be the state's leading daily newspaper. Edward K. Gaylord planned and oversaw the construction of the five-story building at 500 North Broadway. (Griffith Archives.)

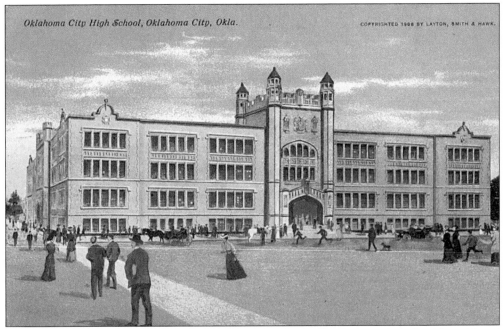

Oklahoma City High School, Oklahoma City, Okla. COPYRIGHTED 1908 BY LAYTON, SMITH & HAWK.

THE CARDINALS OF OHS. When the need for a new high school arose, the school board hired the firm of Campbell & O'Keefe to construct this imposing structure at a cost of $430,000. The Oklahoma High School occupied the block facing Robinson between Seventh and Eighth Streets until the last class graduated in 1968. Today the building is home to One Bell Central. (Griffith Archives.)

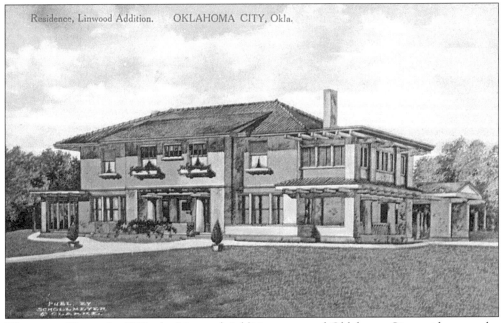

Residence, Linwood Addition. OKLAHOMA CITY, Okla.

WORKMAN HOME. In 1911, the Linwood Addition attracted Oklahoma City residents to the new $12,000 home of O.P. Workman of the Workman Real Estate Company. The two-story home was constructed by L.G. New & Son at 3205 Northwest 19th Street. (Griffith Archives.)

18

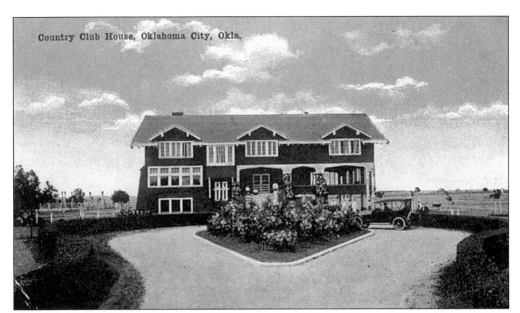

Country Club House, Oklahoma City, Okla.

OKLAHOMA CITY GOLF & COUNTRY CLUB'S SECOND HOME. The city's first golf course was a small sand green east of the Maywood Addition. The formal organization of the Lakeview Country Club took place on April 10, 1907. The club was reorganized and renamed the Oklahoma City Golf & Country Club in 1912, and the members assumed possession of this $15,000 clubhouse at 39th and Western. (Griffith Archives.)

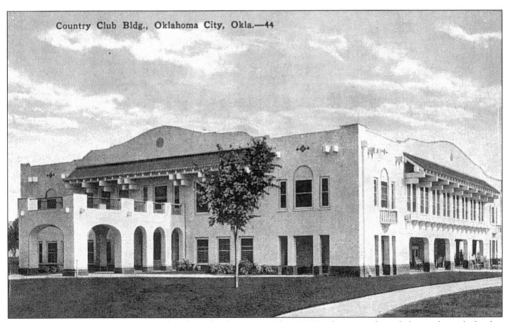

Country Club Bldg., Oklahoma City, Okla.—44

THIRD HOME. By 1922, membership had increased to 840, forcing the club to demolish the older clubhouse and build this larger structure on the same site. The members occupied this building until 1930, when they relocated to their present location in Nichols Hills. The Crown Heights Christian Church purchased the clubhouse and used it for their church until the early 1940s. (Griffith Archives.)

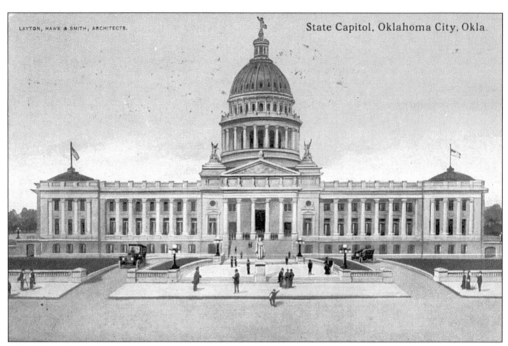

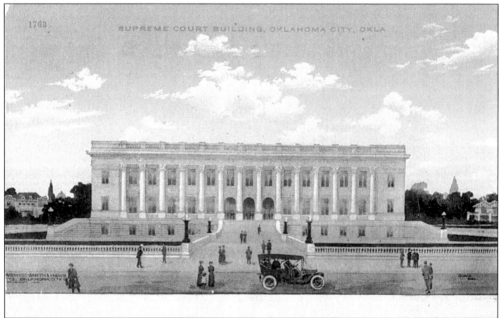

THE PROPOSED NEW CAPITOL PARK. The state hired the firm of Layton, Wemyss-Smith, & Hawk to design the new Capitol Park. The architects proposed a long mall with a series of government buildings stretching the entire length and an Arch d'Triumph at the end. The State Capitol building was to have a dome with eagles flanked on either side. The two-story State Supreme Court Building was to occupy a plaza on one side of the capitol, while the State Agriculture Building stood on the other. In keeping with a symmetrical plan, the Governor's Mansion was designed to serve as both a residence for the chief executive and a state reception hall. (Griffith Archives.)

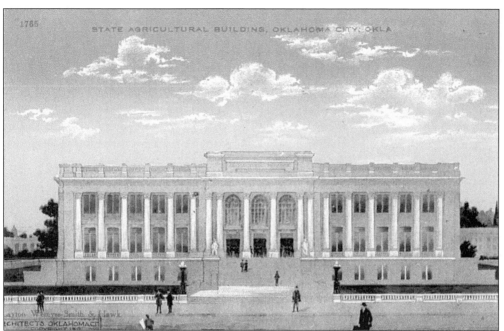

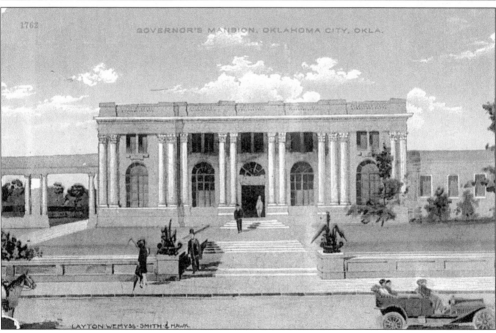

21

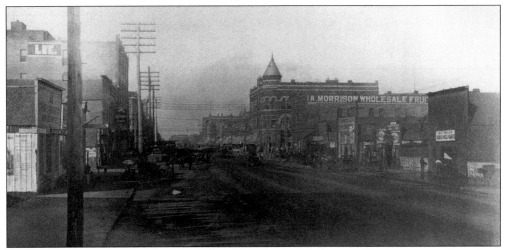

W.T. HALES'S HORSE AND MULE MARKET, C. 1907. One would never guess that when William T. Hales began his business of selling and trading horses and mules, it would lead to a pot of gold. His stables and barn appear on the right of this photograph. The T.J. Griffith Implement Company and the A. Morrison Wholesale Fruit Company were located next door. Across the street from Hales was the OK Stamp and Printing Company, and the Empire Laundry with their livery wagons out front. This view looks south along Broadway. (W.F. Harn Collection held by Elizabeth Bradford, Oklahoma City.)*

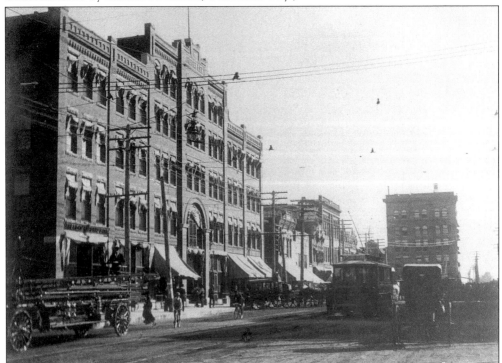

THE LEE AND CULBERTSON BUILDINGS, C. 1907. Continuing south from the view in the above photo, one would end up at the Culbertson Building, later renamed the Broadview Hotel. The Hotel Lee is visible on the left with a hook and ladder fire truck to the left. (W.F. Harn Collection held by Elizabeth Bradford, Oklahoma City.)*

Three

THE CITY

For the first time since 1889, the city government would not be controlled by the purse strings or the "black book" of Big Anne Wynn. The population of Oklahoma City was 55,849 in 1907 and vice was the central issue in the city elections. The citizens were bound and determined to clean up the image left during the territorial years. Oklahoma City was a modern metropolis and it flourished until 1918. This prosperity was stimulated in part by the addition of major railroad lines during the previous decade, under the leadership of Henry Overholser and C. G. Jones. The merchants and area farmers held an economic advantage over other cities in the region, making Oklahoma City the wholesale and distribution center of the state.

The building boom of 1910 saw construction permits reach $6,937,675. Housing surged from 32,452 in 1907 to 64,205 in 1910. Because of the expanding streetcar system, residents were leaving the central business district and moving into the suburbs. The boom began to slow by 1913 when new building projects totaled only $174,727. After 1917, war purchases helped the economy moderately and no major buildings would be erected until 1926 when permits soared again to $16,800,000. the largest increase since 1910.

By the end of 1929, Oklahoma City was littered with 161 oil derricks, of which 53 were producing and 15 exceeding 60,000 barrels a day. With oil money flowing, businessmen devoted more funds to commercial construction. Plans to change the skyline were in full swing until the stock market crashed on what would be known as Black Friday. The Depression would usher in a new era that would change the character of Oklahoma City and her citizens.

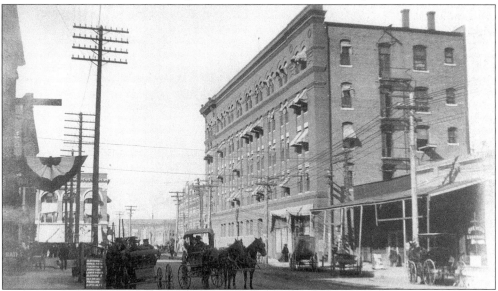

BROADWAY CONTINUES, C. 1907. Past the "jog" at Grand Avenue, one would continue south along Broadway. On the left at the intersection of California is the Rasbach Hotel followed by the city hall. On the left is the Brickworker's Exchange Building and the west side of the Culbertson. The Hotel Lee appears beyond in the middle of the photo. (W.F. Harn Collection held by Elizabeth Bradford, Oklahoma City.)*

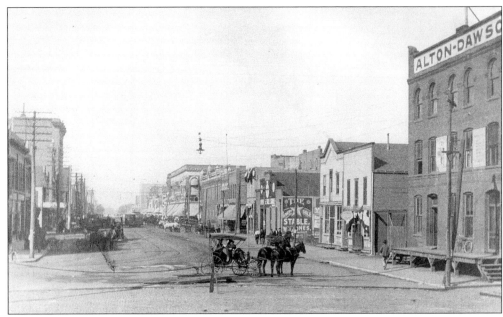

AVENUE "A", C. 1907. This view of Grand Avenue looking west shows the Alton-Dawson Building, which was the last structure before crossing the Santa Fe tracks into the warehouse district. When this photograph was taken, the two madams that ran this section of "Little Gamorrah" had already closed shop. Big Annie Wynn had been acquitted of murder and arson and was on her way to Los Angeles, while "Old Zulu" had turned from her wicked ways and was baptized in the North Canadian River on July 4, 1907. (W.F. Harn Collection held by Elizabeth Bradford, Oklahoma City.)*

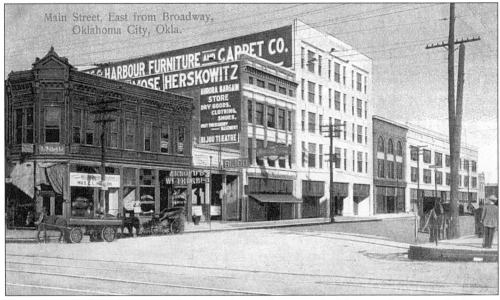

PROGRESS, 1907. Looking towards the northeast, the corner building was known as the Bassett Block which housed the Arnold & Withersbie Electrical Company, and Mrs. C.L. Wilson operated a millinery shop. The Bijou Theater was located next door. Today the Liberty Tower (Bank One) occupies this block. (Griffith Archives.)

24

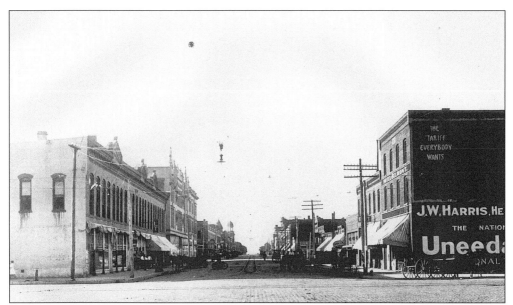

THAT MAN STONE, C. 1909. This view of West Main Street was taken by early city photographer Grover M. Plew, who used the moniker "That Man Stone." This view shows the Hotel Belmont, located at 504 1/2. It appears on the right with the Oxford Cafe a few doors down. (Griffith Archives.)*

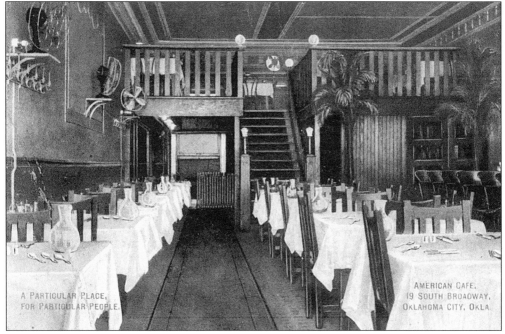

A FIRST CLASS PLACE, 1907. Lawrence A. Davis and his wife Florence opened the American Lunch Room at 19 South Broadway. When this view was taken in 1907, the couple had changed the name to the American Cafe. This "fast food" restaurant boasted linen tablecloths and napkins, a water bottle for each table, electric fans for cooking, and palm plants for a pleasing ambiance. (Griffith Archives.)

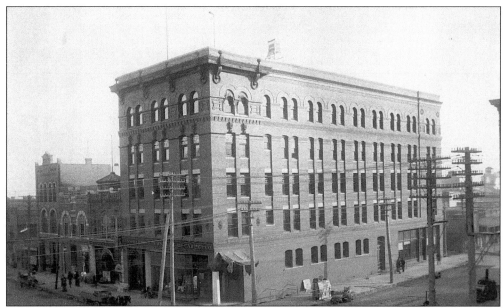

THE SOUTHERN CLUB, C. 1909. Otto Ewing was the bartender of the Southern Club, which was located next door to the Bass and Harbour Furniture and Carpet Company. Otto worked at Ford's Saloon in Lake City, Colorado, when "Red" Kelly shot and killed Bob Ford for shooting Jesse James in St. Joseph, Missouri. Kelly met a similar fate in the notorious Harlet's Lane District on West Second Street. This view looks to the southeast with Grand on the left and Broadway on the right. (Griffith Archives.)*

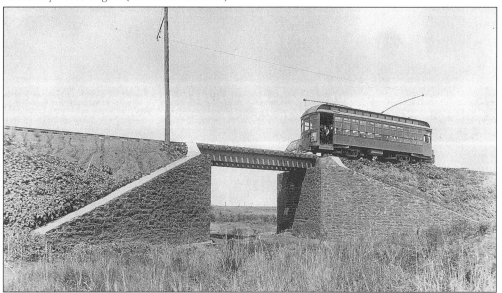

RIDE THE NO. 51, 1909. Real estate speculators such as Anton Classen, W.L. Alexander, J.M. Owen, John Shartel, and W.F. Harn controlled the expansion of Oklahoma City with their promotion of an electric streetcar and interurban rail system. Their leadership in land development funded the electric rail system from 1902 to 1916, in an effort to guide urban growth towards their real estate holdings. Here the No. 51 heads out of Oklahoma City towards the township of Britton on June 9, 1919. (Griffith Archives.)*

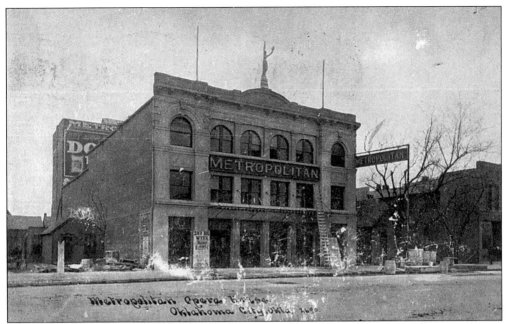

THE METROPOLITAN, 1909. Located at 320-322 West Grand, the theater opened in January of 1909, across from the Terminal Building. Lon Chaney worked as a stagehand at the Metropolitan after working at the Overholser Opera House. Labor problems surfaced in 1929 because the Metropolitan was the only non-union theater in the city, and it was shut down in July of the same year. (Griffith Archives.)

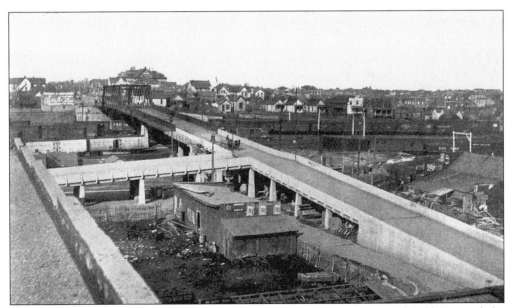

THE VIADUCT, 1909. This view looks to the east towards the Maywood Addition and the Walnut Street Bridge, a portion of which is steel. The Chicago, Rock Island, & Pacific tracks are visible, as well as the Main Street ramp connecting onto the bridge. (First Annual Report, Oklahoma State Corporation Commission Collection of the Archives and Manuscripts Division of OHS.)*

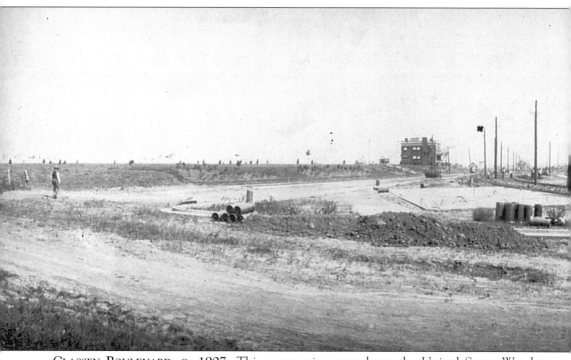

CLASSEN BOULEVARD, C. 1907. This panoramic scene shows the United States Weather Bureau, Department of Agriculture, in the background as two interurbans pass each other. The

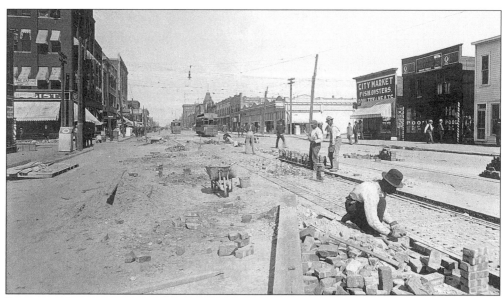

BETWEEN HUDSON AND HARVEY, 1907. This photo shows work crews laying brick along the recently laid streetcar tracks on Grand Avenue. Weavers Drug Store can be seen on the left, as well as the upper portion of the Overholser Opera House. The Grand Avenue Hotel is approximately where the back streetcar is located. The City Market is easily visible on the right. (Griffith Archives.)*

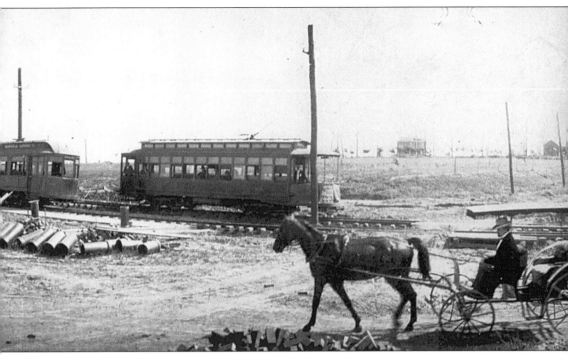

car on the right has a banner that partially reads, "Putnam Park Theater." (Griffith Archives.)

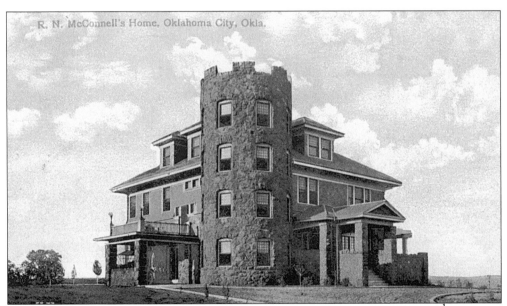

R. N. McConnell's Home, Oklahoma City, Okla.

MCCONNELL HOME, C. 1909. Listed in the 1909 city directory as "southeast of 63rd Street and Western Avenue," the Russell N. McConnell home was very unique. Architects refer to this as an "architectural conceit," for it cannot be attributed to a specific era or a recognized style. The four-story crenelated tower gave this home its characteristic look. (Griffith Archives.)

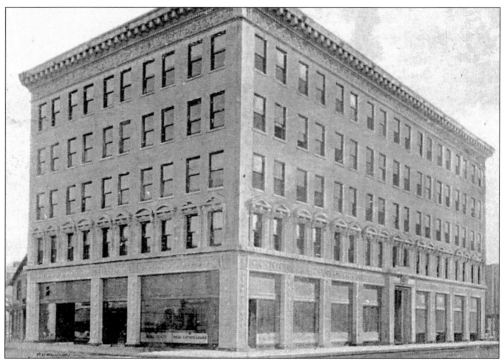

LEVY BUILDING, C. 1907. Constructed as the Levy Building, it was later renamed the Mercantile Building. This five-story structure was located on the southeast corner of Main and Hudson. (Griffith Archives.)

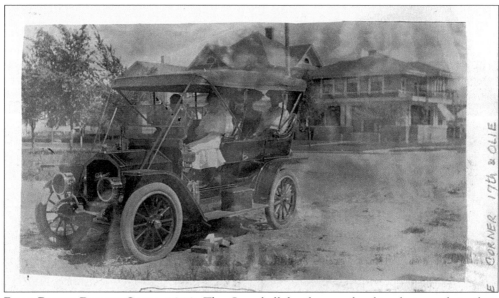

REAL PHOTO POSTAL CARD, 1910. The Campbell family pose for this photograph in their 1910 Model 10 Buick. The back of the card reads; "You can get a pretty good idea of how the new car looks by this." Edgar, Agnes and C.S. Campbell lived at 1001 W. 17th Street. (Streeter B. Flynn, Jr. Collection.)

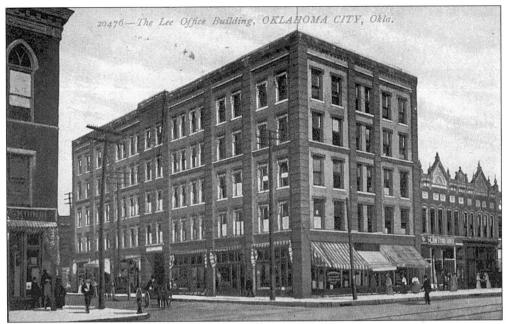

LEE OFFICE BUILDING, C. 1907. The Lee Office building on Robinson and Main Streets was first occupied by the American National Bank. Oscar G. Lee sold the structure in 1920 to Liberty National Bank, and the building sold again in the mid-20s when it was renamed the Oil and Gas Building. (Griffith Archives.)

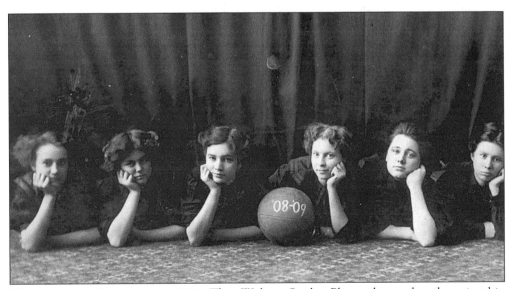

WE ARE THE CHAMPIONS, 1908. This Walton Studio Photo shows the championship basketball team of the Oklahoma High School in 1908. (Griffith Archives.)*

WILLIAMSON HOME, C. 1908. This postcard was used as a Christmas card in 1908. Tucker W. Williamson built this fine residence at 408 North 13th Street. Dennis T. Flynn received this card and the reverse reads, "Christmas Greetings and much love from the Williamson family to you and yours, M.L.W." Mary L. was the secretary/treasurer of the Williamson-Halsell and Fraiser Company, wholesale grocers. (Streeter B. Flynn, Jr. Collection.)*

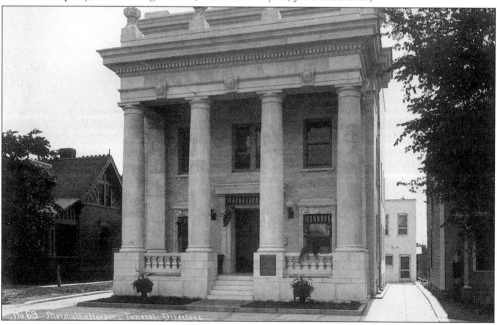

THAT MAN STONE, 1909. Along with Street & Reed Undertaking, the firm of Marshall & Harper catered primarily to the families of the "carriage trade." Ed L. Hahn worked as an embalmer and lived in the garage apartments in the back. This impressive building was used until James H. Marshall and William E. Harper left the downtown area and moved to the Paseo District, at which time Ed Hahn opened his own funeral home. Today all firms have merged and are known as Hahn-Cook / Street & Draper. (Griffith Archives.)*

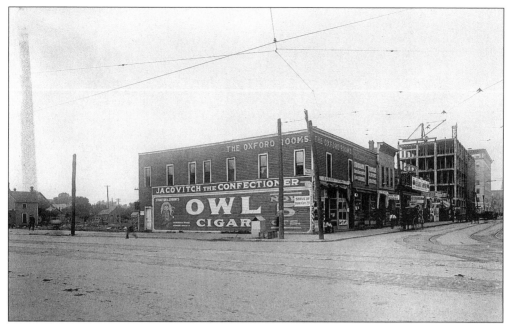

THE SOUTHEAST CORNER OF GRAND AND HARVEY, C. 1909. This photographer stood here on the corner of Grand and Harvey to capture everyday life on June 14, 1909. The Oxford Rooms Hotel sits at the intersection of the 200 block. Following to the right are the Jacovitch Confectioners at 210 North Harvey, and the Majestic Building, under construction at 103 North Harvey. (Griffith Archives.)*

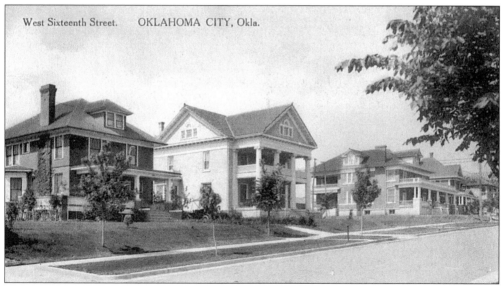

WHAT A SCENE, C. 1909. Pictured from left to right are several fine structures, beginning with the home of attorney Rudolph A. Kleinschmidt at 628 West Sixteenth. He had offices in the Insurance Building. George A. and Margaret Todd were next door at 632. George and his brother Hugh owned and operated the Oklahoma Refining Company. Located across the street at 700, was the residence of William B. Skirvin, founder of the Skirvin Hotel and father of Ambassador Perle Skirvin Mesta. (Griffith Archives.)

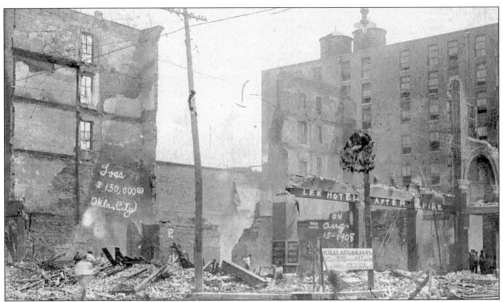

A Total Loss. The city skyline was a bright red and yellow on August 15, 1908, when the Lee Hotel burned to the ground with a loss of $150,000. The papers reported that the fire was visible from as far away as Yukon to the west, Edmond to the north, and Harrah to the east. The Campbell building, visible to the right, was not badly damaged in the blaze. (Griffith Archives.)

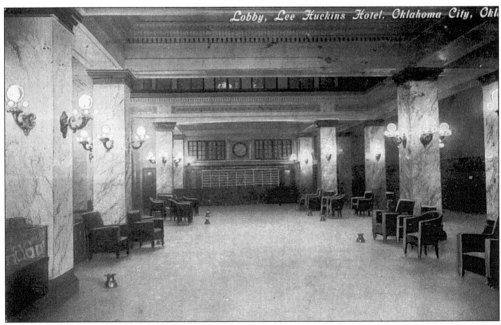

Time to Rebuild, 1909. After the fire of August 15, 1908, the new Lee-Huckins Hotel offered the finest accommodations to the weary traveler. These three postcards show the new interior of the hotel. The spacious lobby greeted guests to relax or visit with other guests or clients. Note the spittoons for added convenience. The ballroom was often rented out for parties. Not wanting their female guests to be left out, the Lee-Huckins offered a quiet and spacious ladies lounge. (Griffith Archives.)

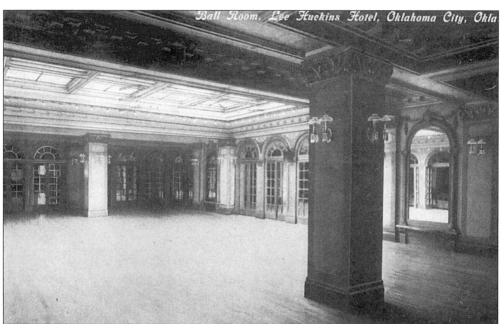

Ball Room, Lee Huckins Hotel, Oklahoma City, Okla.

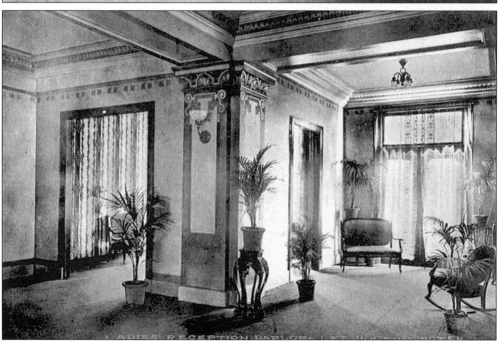

Ladies' Reception Parlor, Lee Huckins Hotel.

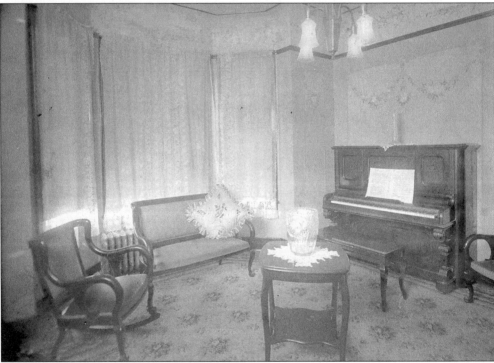

THE JAMES A. RYAN HOME, 1909. Located at 400 West Tenth Street, this buff brick residence was the home of Dr. and Mrs. J.A. Ryan. Dr. Ryan was the chief of staff at St. Anthony Hospital. These photographs taken by "That Man Stone" show a glimpse of the interior rooms. The first shows the music room, which was located off the main parlor. As seen in both views, these rooms were covered in canvas and hand-painted to compliment the wall-to-wall carpeting. The unusual archway that divided the parlor and music room was hand-hewed from oak. The last view shows the dining room, which has cut crystal on display. The plates along the wall were probably hand-painted by Mrs. Ryan or given to her as gifts. (Griffith Archives.)*

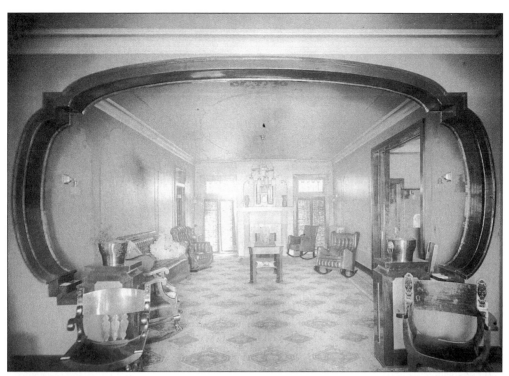

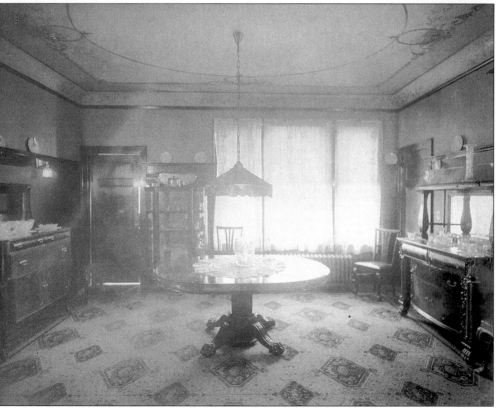

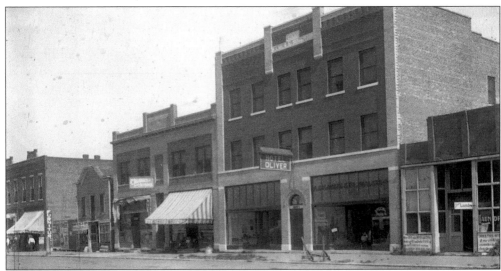

CALIFORNIA BETWEEN ROBINSON AND HARVEY, 1909. The scene shows a portion of California Avenue practically deserted of any human presence. Various businesses occupied these buildings, including the Lee Sam Laundry, the F.L. Mercantile located in the Houghton Building built in 1908, which housed the Oliver Hotel. There is a car dealership, furniture store, photo supply shop, the Edgar Plumbing Supply, a gunsmith, upholster, the Henry Moritz barbershop, and a pool hall on down the block. (Griffith Archives.)*

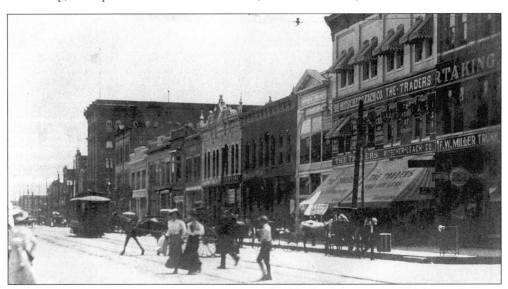

MANY CHANGES, C. 1911. From 1909 to 1911, this block of downtown Oklahoma City saw many changes, some leaving their mark. This photograph looking east from Robinson onto Grand Avenue shows the same group of buildings as the photograph on the right, with the exception of the last structure on the right, the Mitschner-Leach Company at 126-128 West Grand. It was once home to Bass & Harbour Undertaking. Following on the left, the white three-story building at 124 is the Bartin-Gayke Shoe Store and the Nation Company. The current home of the Street and Draper Funeral Home (old Classen Company Building) is located at to the left at 122, and Isadore Rubin Gentlemen's Furnishings is at 120. (Bertha M. Levy Collection of the Archives and Manuscripts Division of OHS.)*

OKLAHOMA CITY WATER DEPARTMENT.

MAY 31 1909 ACCOUNT NO. *1690 M*.

Present Meter Reading ... *11930*

Previous Meter Reading ... *6600*

Amount Due $ *105*

NOTICE

N. B. In case the Water Rent is not paid in 10 days from date of this notice the water will be turned off and not turned on again until Water Rent is paid, and $1.00 additional for labor.

IT SLIPPED MY MIND. Postmarked 3 p.m. on May 31, 1909, this notice from the city water department shows that account number 1690M has but ten days to pay the $1.05 bill or their water will be turned off. Notice the wording in the box stating, "In case the Water Rent is not paid . . ." How do you rent water? (Griffith Archives.)*

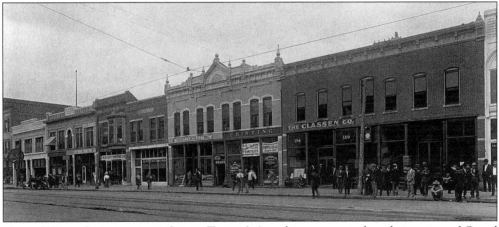

KNOW WHAT OCCUPIES THIS SPACE TODAY? A parking garage today, this section of Grand Avenue held a variety of businesses back in 1909. Beginning at the left, the Batchelder Building, which houses the Larimore Hardware Company, is located on the corner. The Bres-Hubbell Drug Company is located at 102 West Grand, Milos Cafe is next door at 104-06, and the American Express Company is at 108. Levy Brothers Furniture & Whitley Furniture share the same building at 110-112, with the Street & Draper Undertakers at 114 and the C. Brahm Billard & Pool Hall at 116. The OK Stamp & Printing Company occupies 118 with the Classen Companies next door. The Classen Company was several small enterprises owned by capitalist Anton Classen. It included the OK Electric Terminal Company, the University Development Company, Belle Isle Improvement Company, and the Oklahoma City Live Stock Company. Classen's partner, John Shartel shared a law practice, Shartel, Keaton, & Wells. The white building to the far right housed the Nation Company, which manufactured harnesses. (Griffith Archives.)*

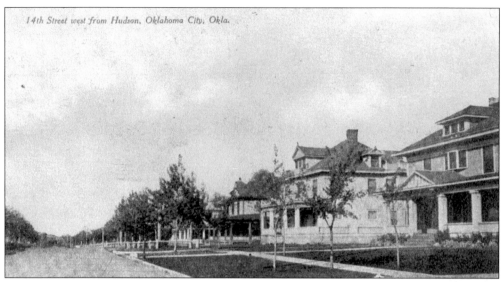

14th Street west from Hudson, Oklahoma City, Okla.

14TH STREET, HUDSON, C. 1909. The C.B. Ames home (at 305) and the 1903 George Sohlberg home appear in this view looking west along the north side of Fourteenth Street at Hudson. By 1910, the Ames home was relocated and a new residence was built. The porch on the Sohlberg home was also removed. Today two brothers live in these dwellings, Dr. Joe Coley on the site of the old Ames home and Capt. Charles Coley in the Sohlberg residence. (Captain Charles and Dorothy Coley Family Archives, Oklahoma City.)*

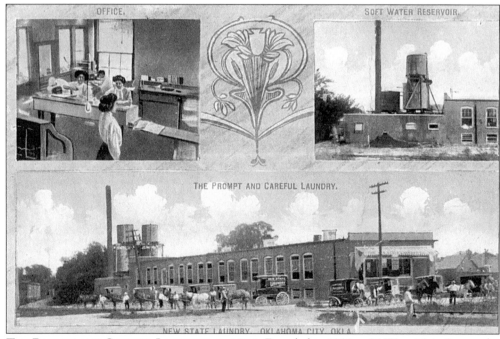

THE PROMPT AND CAREFUL LAUNDRY, C. 1911. Founded in 1909 at 24 West Main Street, the New State Laundry moved to 118-120 North Francis in 1911. This multi-view postcard shows a very modern facility with a staff equipped with the most modern steam and electric power machinery, and horse-drawn delivery wagons. (Griffith Archives.)

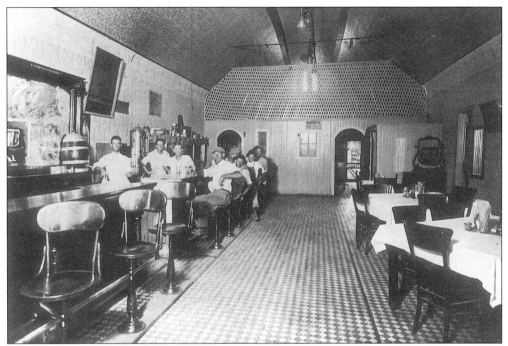

STAR CAFE. M.A. Cohn was the proprietor of the Star in 1909. The cafe's motto was "Cleaness and quick service." The restaurant's name was changed in 1911 to the Katsiolis and Tusalos Restaurant, after owners Gus and Tony. (Charles Turner Hocker Collection of the Archives and Manuscripts Division, OHS.)*

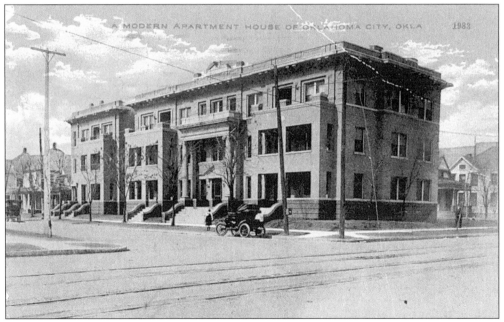

THE VICTORIA, C. 1909. The postcard reads, "A modern apartment house." Located on the northwest corner of Broadway and West Ninth Street, the Victoria Flats had multi-family living units. The automobile out front is a 1904 Oldsmobile. (Griffith Archives.)

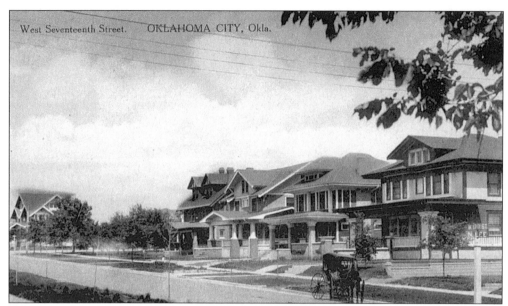

ALL GROWN UP, C. 1909. Today the saplings in this postcard form an arch as they shade the street below. The horse and buggy are pictured at 705 North Seventeenth at the home of Mose Baum, who built the magnificent Baum Building with his brother Marx. Next door at 709 is the home of Meyer Benson, proprietor of Benson's Ltd., a second-hand clothing store located at 107 West Main. Insurance agent Merton A. Hassenflue lived at 711, and Joseph C. McClelland, president of the Tradesman Bank, lived at 719. McClelland built his home sometime in 1908. (Griffith Archives.)

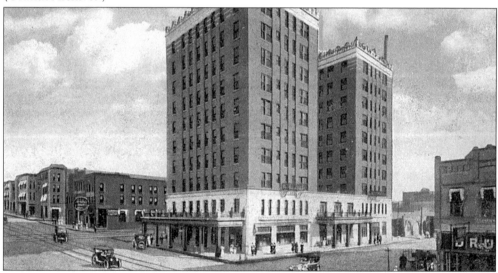

THREE HUNDRED-ROOM HOBBY, 1909. In 1909 Colonel Ned Green of New York called on William Skirvin at his Geary Street residence. He had been sent by his mother, Hetty Green, to purchase property. After looking all over the city, Col. Green decided on four lots at the corner of First and Broadway. Skirvin owned those four lots and since the offer was substantial, he was almost ready to agree to the sale when Green mentioned that his mother planned to build the biggest hotel in Oklahoma City on the land. Skirvin immediately turned down the offer. (Griffith Archives.)

42

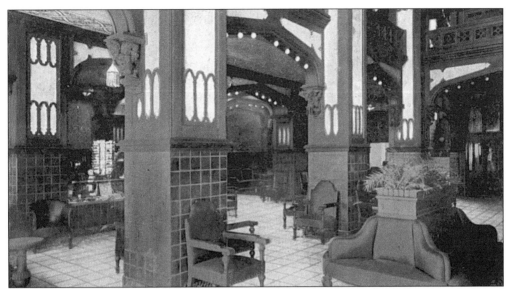

THE LOBBY. Looking southeast in the lobby of the Skirvin, the front doors appear on the right. The entrance to the dining room can be seen in the center of the photograph and the gift stand is on the left. (Griffith Archives.)

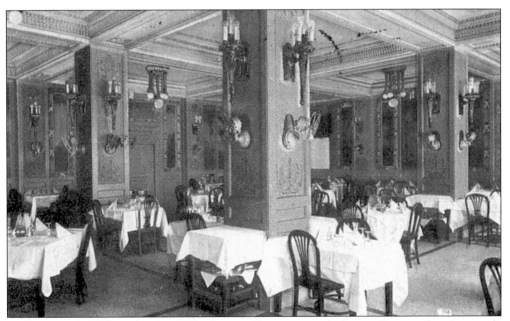

DINING ROOM. What elegance! The large wall sconces and electric fans on the piers made dining at the Skirvin an affair to remember. Note the water carafes on each table. (Griffith Archives.)

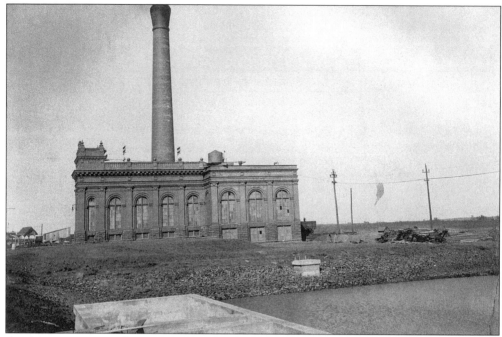

An Architectural Gem, 1910. A nice close-up of the Oklahoma Railway Company Power House shows its location on the shores of Belle Isle Lake. (Archives and Manuscripts Division of OHS.)

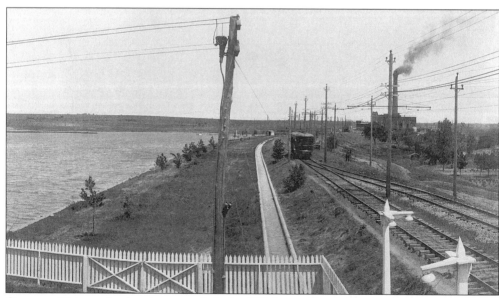

Getting There. As the city expanded, the Oklahoma Gas & Electric Company could not always provide the power that the Oklahoma Railway Company needed. On occasion, streetcars and interurbans became stranded when the power company cut its transmissions to the railway to prevent brown outs. To stop this, the interurban focused on the construction of this power plant and the promotion of a central terminal for passengers. This photograph shows a view of the power plant, No. 51, and the docks. (Griffith Archives.)*

Four
BELLE ISLE

Since the turn of the century, there has always been a close connection between amusement and transportation in the United States. While many people enjoyed "getting away," they didn't want to travel far for relaxation. For Oklahoma City residents, most areas of recreation could only be reached by automobile, horse, or streetcar. Since traveling by horse took too long, and most residents couldn't afford an automobile, the streetcar was the ideal method of travel. Realizing the demand for such a transportation service, the streetcar companies invested in amusement and entertainment facilities. The Oklahoma Railway Company operators of the city streetcar system, owned Belle Isle Park and Lake. Their cars carried hundreds of visitors during the summer months to the parks for swimming, boating, dancing, and other park attractions. The park boasted a two mile lake with boating areas and a water theme park. Use of the park for picnicking and boating was free. Belle Isle had competition from other parks that were located closer to the neighborhoods, where a short walk would find you at Shepherd Lake for pony rides, swimming, and refreshments at the Orange Julius stand, or perhaps at Putnam Lake. There were other parks—Dreamland in the 100 block of West Main Street, Elmwood Park in Southtown, Colcord Park, or the zoo at Wheeler Park—but none offered attractions like Belle Isle. By 1910, the Delmar Gardens had lost its appeal: too many mosquitoes and not enough beer.

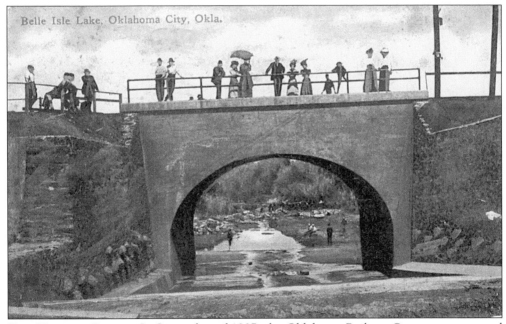

THE VIADUCT BRIDGE. In September of 1907, the Oklahoma Railway Company contracted with the Belle Isle Improvement Company (an Anton Classen holding) to use the Belle Isle Park's water supply to generate power and to use park land for a power plant. For those favors, Belle Isle received one dollar. (Griffith Archives.)

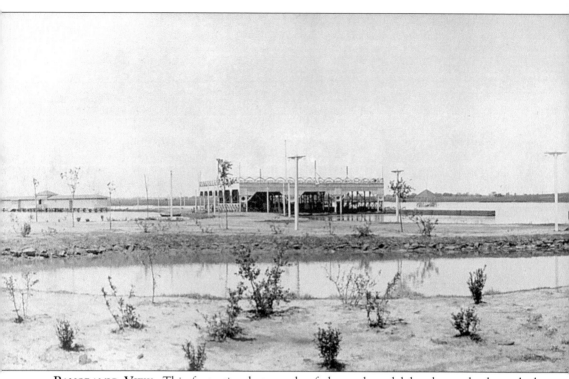

PANORAMIC VIEW. This fantastic photograph of the park and lake shows the boat docks,

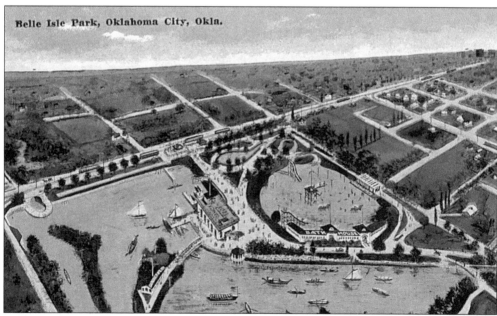

WHAT A PLACE! This is the artist's idea of what Belle Isle Park and Lake would look like when completed. This view looks southeast from Rose Hill Burial Park. Today, the old park is now occupied by Penn Square Mall. (Griffith Archives.)

pavilion, lake, and power plant. (Griffith Archives.)*

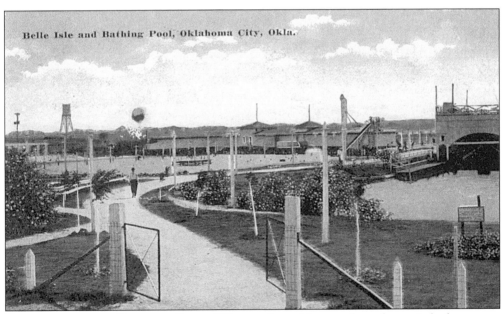

Belle Isle and Bathing Pool, Oklahoma City, Okla.

ENTRANCE TO THE BATHING POOL. What a place this must have been. It had so many activities from which to choose. (Griffith Archives.)*

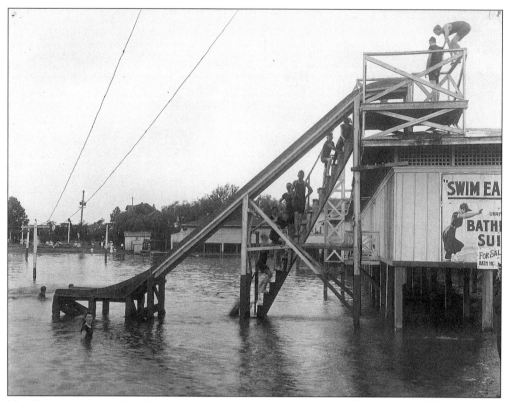

NO BATHING SUIT? NO PROBLEM. The sign on the right reads "Swim Easy—The Unrivalle Bathing Suit—For Sale in the Bath House." These young lads take a moment to pose for the camera at the Belle Isle theme area. (Griffith Archives.)*

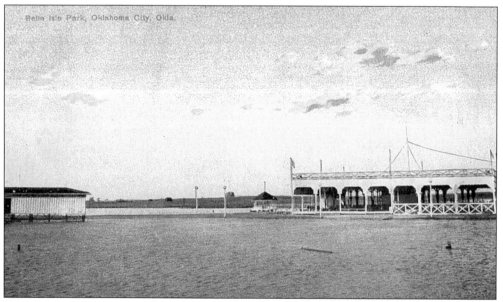

THE DOCKS. A person could rent a small rowboat for just pennies and spent the entire afternoon with his or her beau. The boat docks were kept well stocked. (Griffith Archives.)

WHAT FUN, C. 1912. Spending the day at Belle Isle Lake was a great way to cool off. Trying to stay up on these wooden devices is harder than it looks. (Griffith Archives.)*

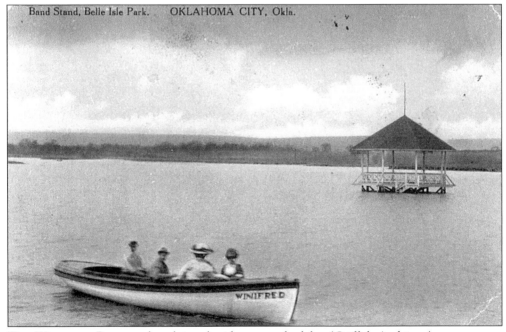

Band Stand, Belle Isle Park. OKLAHOMA CITY, Okla.

WINIFRED

THE WINIFRED. Boaters take a leisurely ride out on the lake. (Griffith Archives.)

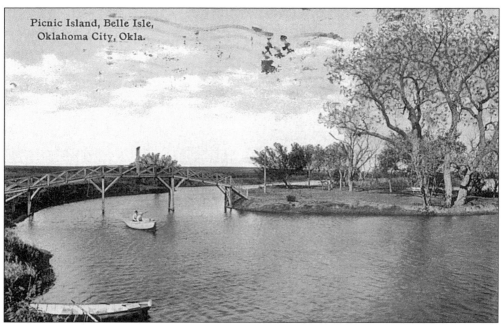

LUNCH TIME. Couples could take a break for a picnic lunch of fried chicken, deviled eggs, and fresh peaches on Picnic Island. (Griffith Archives.)

A CORNER IN BELLE ISLE TO READ. When room ran out on the back, the sender continued, on the front, "Zona is here and is reading book will send as soon as she is through." Mrs. D. (Griffith Archives.)

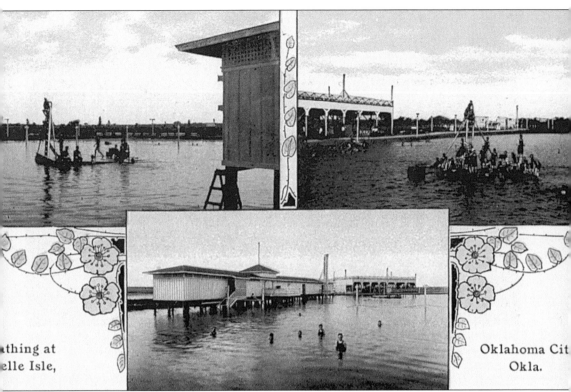

thing at
elle Isle,

Oklahoma Cit
Okla.

ONLY A MEMORY. Belle Isle closed down when rival park Springlake opened. Gone were the days of swimming in a lake—Springlake had a cement pond. (Griffith Archives.)

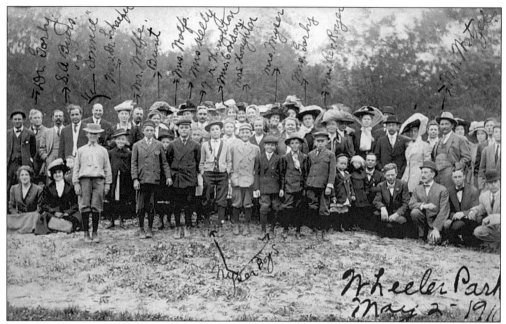

MAY DAY, 1910. This gathering took place at Wheeler Park on May 2, 1910. Pictured from left to right are as follows: Dr. Gorly, S.A. Byers, "Sonnie," Dr. & Mrs. Schaefer, Mr. Wolfe, "Bunt," Mrs. Wolfe, Mrs. Kelly, Mr. Houghton, Mrs. Myser, Mrs. Gorly, Mrs. Royer, and Mr. Wetzel. The two Myser Boys are in the front of the picture. Their parents owned the Myser China Shop. (Griffith Archives.)*

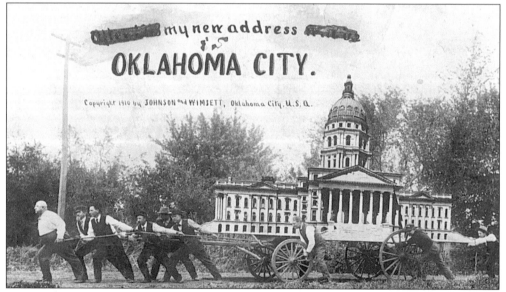

WE HAVE THE CAPITOL, 1910. This postcard originally read, "After 1918 my new address will be Oklahoma City." The capitol fight of 1910 changed this promotional card for the architectural firm of Layton, Smith, and Hawk. The back of the card reads, "Oklahoma City, 6/14/10. Dear Bro.—Irin is now convalescent—had no fever for 8 days. Has not set up any yet. We now have the State Capitol—Have you read about it in paper? Everything going nicely now. Love to all—U.M.B." (Griffith Archives.)

INSURANCE BUILDING, 1910. Prior to this building's construction, various architectural firms drew plans for a building of similar size for this same site at 114 North Broadway. The Oklahoma Gas & Electric Company had their offices in the building to the right for a short time. The need for additional space led the company to extend its occupancy to the Insurance Building. (Griffith Archives.)

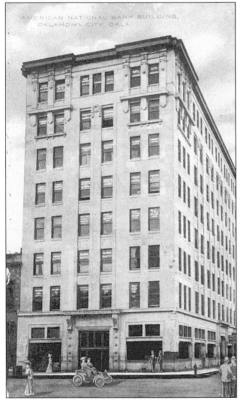

AMERICAN NATIONAL, 1910. The American National Bank was founded by Frank Johnson in 1910 in the old Lee Office Building at 26 North Broadway. In 1909, construction began on this building at the corner of Main and Robinson. It was the bank's home until 1927, when the American merged with the First National to become the American-First National Bank. (Griffith Archives.)

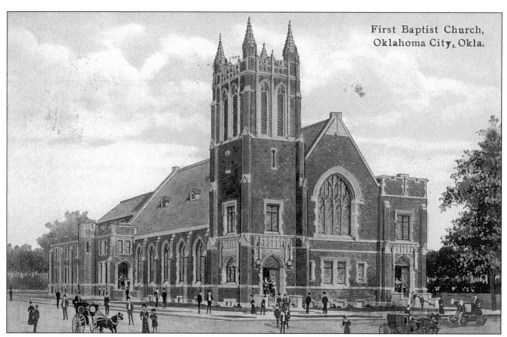

First Baptist Church,
Oklahoma City, Okla.

BAPTIST WHITE TEMPLE, 1910. The congregation of the Baptist White Temple outgrew their church building and made plans to construct a new church home in 1910. A new First Baptist Church was erected on the northwest corner of Eleventh and Robinson that same year. It was built of red brick with white stone, and the facade was graced by a beautiful stained-glass window. As seen in the second photo, a new educational wing was added in 1930. The First Baptist Church has continued to expand over the years and remains at the same location today. (Griffith Archives.)

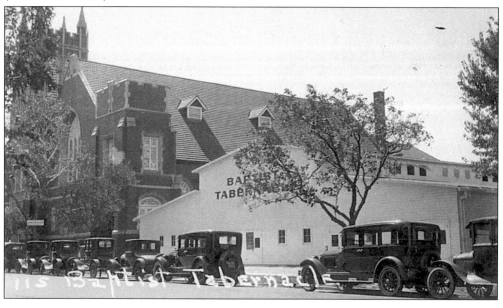

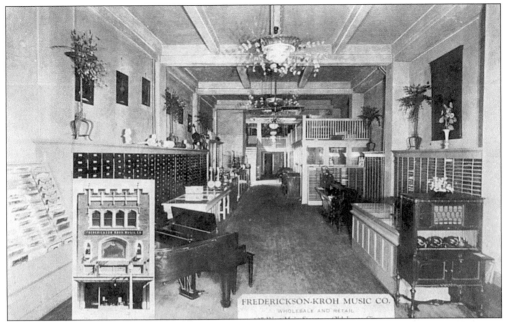

FREDERICKSON-KROH MUSIC COMPANY, C. 1910. Located at 407 West Main, the wholesale and retail music store was operated by George Frederickson and J.L. Constant. Every line of musical instrument or any sheet music could be found or ordered through their quality customer service. (Griffith Archives.)*

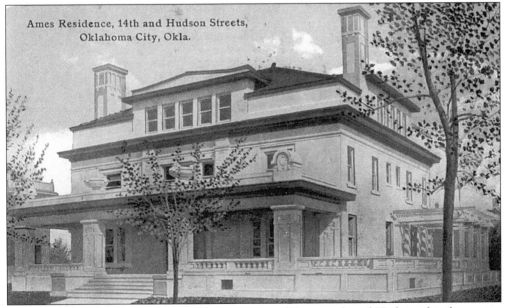

Ames Residence, 14th and Hudson Streets,
Oklahoma City, Okla.

AMES HOME, 1910. Built on the northwest corner of Fourteenth and Hudson, this three-story home was the stately residence of Judge C.B. Ames. He served as presiding Judge of Division No. One of the Supreme Court Commission of Oklahoma, and later as the Assistant to the Attorney General of the United States. In 1902, Judge Ames, along with Dennis T. Flynn, chartered the Oklahoma Gas & Electric Company. The home was built of limestone and has 17-inch thick walls. (Griffith Archives.)

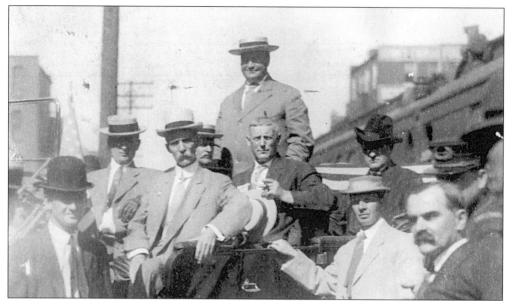

D.C. Delegates, 1910. The back of this postcard reads, "This was taken upon Vice President Sherman's arrival. Papa." The man standing in the center wearing the straw boater is Vice President Sherman. Dennis T. Flynn is below him with boater in hand. (Streeter B. Flynn, Jr. Collection.)*

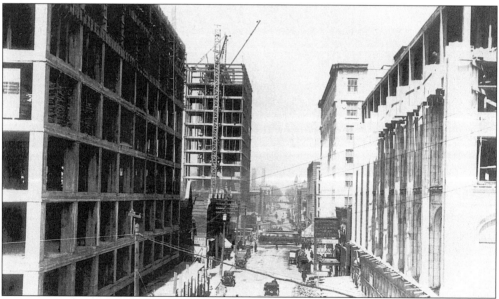

The Canyon, 1910. This view shows the second generation of building that occurred in the boom of 1910. Known as "The Canyon," this photograph shows $1,650,000 worth of construction on Robinson Avenue, beginning at Grand Avenue. On the left is the 14-story Colcord Building followed by the State Theater, the 12-story State National Bank, and the three-story Ketchem Building. In the distance is the new Central High School. On the right of the Colcord is the five-story Baum Building and the American National Bank, which was occupied, but not yet complete at the time of this photograph. (Archives and Manuscripts Division of OHS.)

THE FIVE AND DIME, 1910. Prior to statehood, the S.H. Kress & Co. opened for business in the small three-story building in the center in this photograph. By 1910, the store had expanded to incorporate the Illinois Hotel building to the left. The upper photograph shows the inside of the five and dime store. Merchandise filled the wood and glass counters where customers could purchase writing paper and pens, candy, handkerchiefs, and notions. (Griffith Archives.)

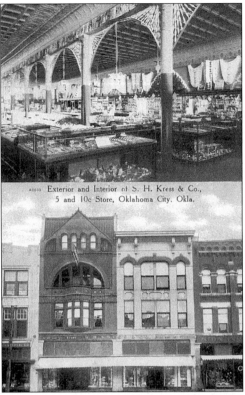

Exterior and Interior of S. H. Kress & Co., 5 and 10c Store, Oklahoma City, Okla.

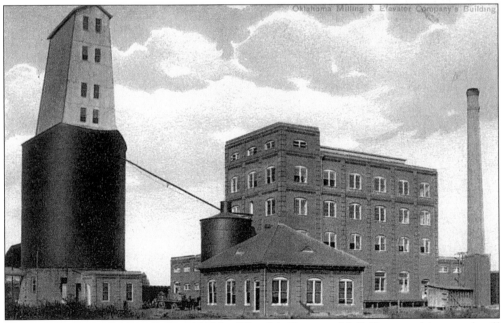

ELEVATORS, C. 1910. Founded in 1889 by Whit M. Grant and L.F. Kramer, this second mill was added to the operation in 1905. Choctaw Flour was the brand name of flour produced by the Oklahoma Mill & Elevator Company. This view shows the mills at West First and Francis. This mill discontinued production in 1953. (Griffith Archives.)

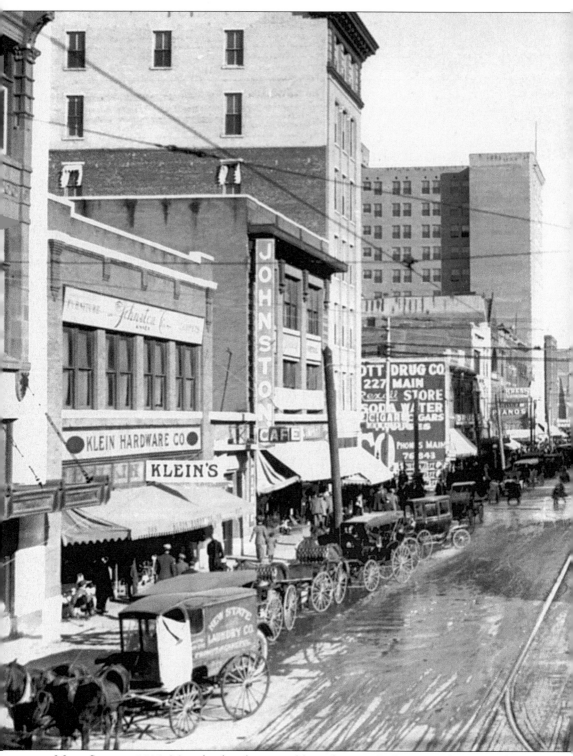

MAIN STREET, 1910. Many landmarks are visible in this view looking east along Main between Harvey and Hudson. There is a silhouette of a 1910 Buick on the left at the Scott Drug

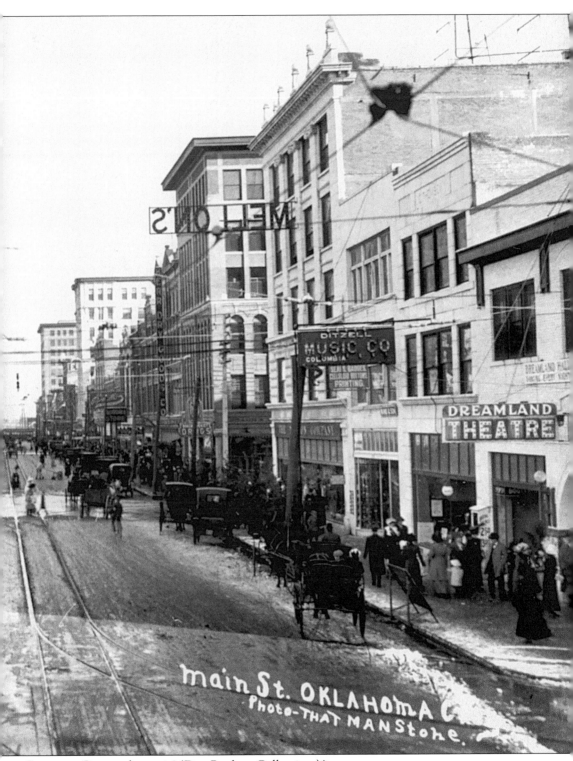

Company. Can you locate it? (Don Boulton Collection.)*

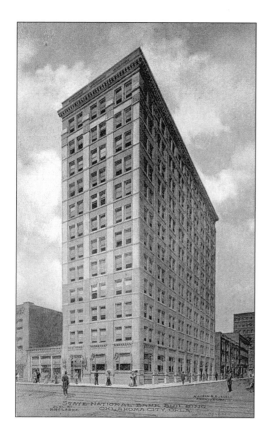

STATE NATIONAL, 1910. Edward H. Cooke made the "Run of 1889" and became one of the city's prominent bankers. Cooke built this twelve-story building and later sold it to William T. Hales in 1915 for one-half interest, after State National merged with First National. Hales renamed the building after himself and it remained a part of the city skyline until it was razed by urban renewal. (Griffith Archives.)

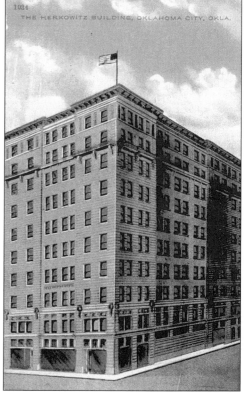

HERSKOWITZ BUILDING C. 1910. Max Herskowitz arrived in Oklahoma City in the late 1890s and built this twelve-story building in the northeast corner of Grand and Broadway Avenues. Until 1910, it housed the Wesley hospital and then the federal government leased the building for wartime apartment housing. After World War II, it was used for downtown apartment until it was razed in 1970. (Griffith Archives.)

THE CUP, 1910. George sent this postcard to his Chicago friend, Robert D. Ferguson, on December 10, 1910. It reads, "This is the cup for the free for all. How do you like it? 20 inches high without the pedestal. I am entered at Indianapolis for the May 27th, 500 mile race. Back at the hotel." (Griffith Archives.)*

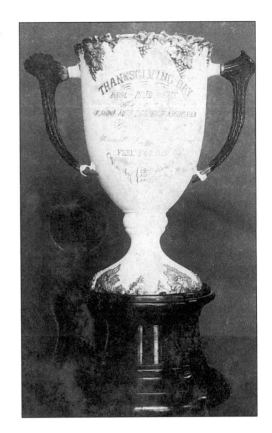

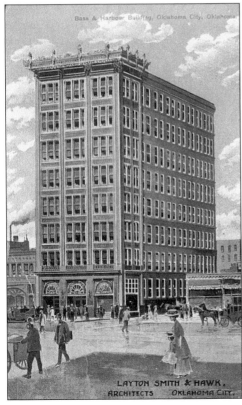

BASS AND HARBOUR, C. 1910. This conceptual drawing shows what was to be built for J.M. Bass and J.F. Harbour at 19-23 West Main. The building pictured here became the Insurance Building at 114 North Broadway. (Griffith Archives.)

61

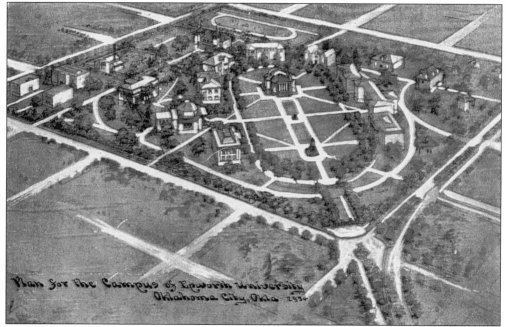

PLAN FOR THE CAMPUS, C. 1910. This artist's conception for the layout of Epworth University never materialized. The center building was based on the administration building at the University of Virginia. (Griffith Archives.)

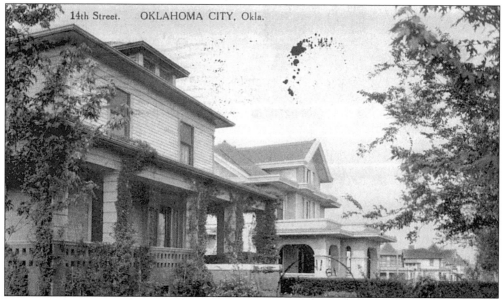

HOTTEST DAY OF THE YEAR, 1910. Stephanie Mencke sent this postcard to her friend Herman Doell of Ft. Wayne, Indiana, on June 23, 1910. She writes, "Weather is terrible hot here. Was boat riding all evening so nice and cool on the lake. Wish you been with me. With love." The scene shows two homes on Fourteenth Street. On the left at 723 is the residence of Solomon Barth, who operated the B & M Clothier (later known as Rothschilds) with Joseph Myer. William Mee, president of Security National Bank, lived next door at 721. (Griffith Archives.)

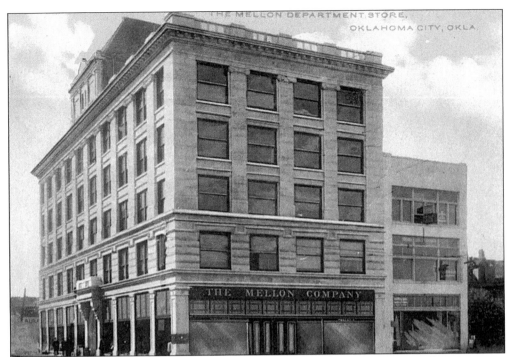

GREETINGS ALL, 1910. Located at 300-302-304 West Main Street, the Mellon Company advertised that this store "contained thirty-six departments, each one a complete specialty store within itself." Built during the building boom of 1910, Marry E. Mellon, widow of founder Thomas P. Mellon, made it a point to greet the first visitor each morning. (Griffith Archives.)

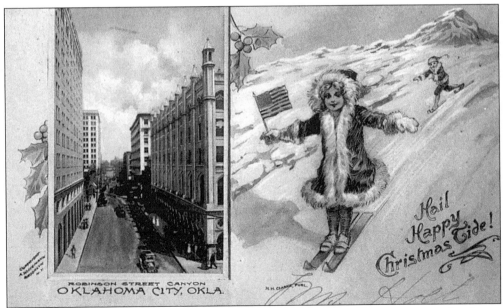

MERRY CHRISTMAS, 1910. Mrs. Holt of Oklahoma City sent this Christmas postcard to her friend, Mrs. Brenda Layette, in Checotah, Oklahoma. The scene on the left is Robinson looking south, down the "Canyon." (Griffith Archives.)*

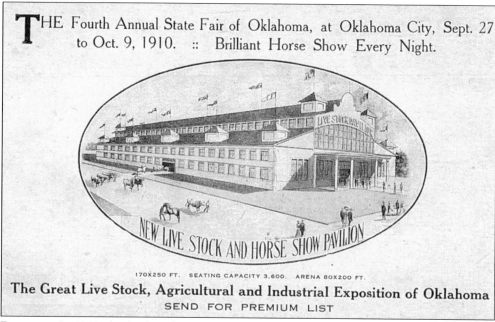

THE Fourth Annual State Fair of Oklahoma, at Oklahoma City, Sept. 27 to Oct. 9, 1910. :: Brilliant Horse Show Every Night.

NEW LIVE STOCK AND HORSE SHOW PAVILION

170X250 FT. SEATING CAPACITY 3,600. ARENA 80X200 FT.

The Great Live Stock, Agricultural and Industrial Exposition of Oklahoma

SEND FOR PREMIUM LIST

PAVILION. In 1910, the fair board found an efficient way to supplement the agriculture displays of counties and individual farmers—the first State Fair Agriculture School. Under the supervision of professors from Oklahoma A & M College, the school handled a fall camp for boys age 14-18 for 12 days. Each county could send two boys. Their tuition would be paid for, but they had to arrange their own transportation. (Griffith Archives.)

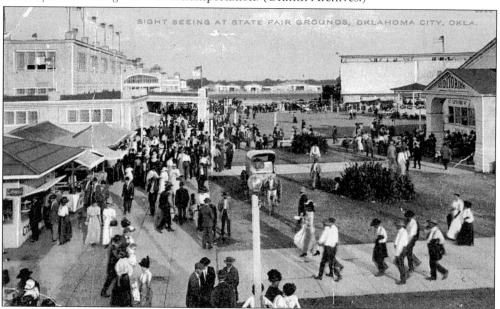

EXPANSION. Construction continued into 1910 and 1911, and the list of new buildings lengthened to include the Mineral Resources Building, an addition to the Agriculture Building, the Women and Children's Building, the Bee and Honey Building, the Automobile and Carriage Building, the A&M College Building, and an "Air Dome" Theater, constructed for six thousand dollars. (Griffith Archives.)

Five

STATE FAIR

At a board meeting on December 24, 1907, Henry Overholser offered to serve as fair secretary for one more year, without salary, provided the fair board employ an assistant secretary. J.T. Stites, who had served as the first secretary, said he did not want to stand in the way of such a generous offer and tendered his resignation. Two days later, Overholser hired his new right-hand man, I.S. Mahan. Isaac Shepherd Mahan was born in Lexington, Illinois. In 1907, at the age of 34, he moved to the country's fastest growing metropolis, Oklahoma City, where he entered the real estate business. In June 1908, he began his new career with the State Fair of Oklahoma with a salary of $75 a month. For the next five years, Overholser and Mahan would dominate the affairs of the state fair. If the fair was to grow and prosper, the number and quality of the facilities had to improve.

Pressed by financial need, the board of directors increased the capitalization of stock from $100,000 to $200,000 in April of 1908. By June, only $53,958 had been paid on all stock subscriptions, including those pledged the previous year. Again, Overholser loaned another $23,000 to the fair association for improvements, bringing his total cash layout to more than $85,000. The total attendance of the 1908 fair was estimated at 100,000, a 25 percent increase over the first fair.

For the next three years, improvements on the fairgrounds began with a new agriculture building. No project received as much comment in the press as the planting of Bermuda grass on the entire grounds.

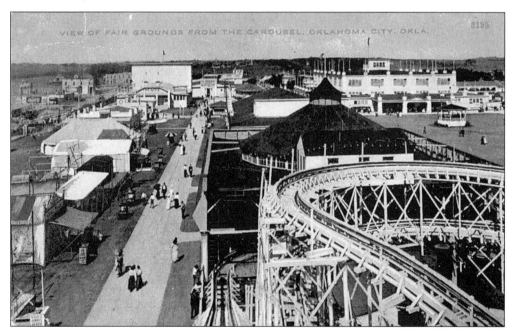

MISLABELED POST CARD. The photographer stood on the highest point of the roller coaster, not the carousel, for this marvelous view of the fairgrounds. In 1910, Henry Ione Overholser, age 5, drove her electric car through the grounds. (Griffith Archives.)

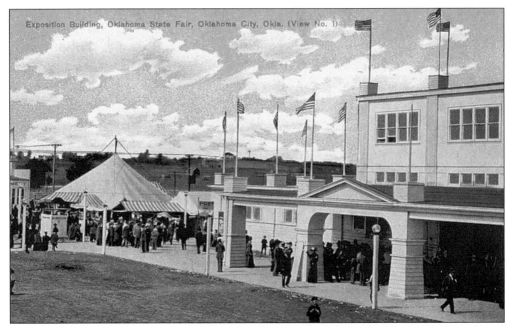

Exposition Building, Oklahoma State Fair, Oklahoma City, Okla. (View No. 1)

NEW POWER PLANT. A new electrical power plant supplied all fair buildings. The grandstand and racetrack was equipped with 17 arc lamps for night events. The entire fairgrounds had 40 telephones for the convenience of the fair patrons. (Griffith Archives.)

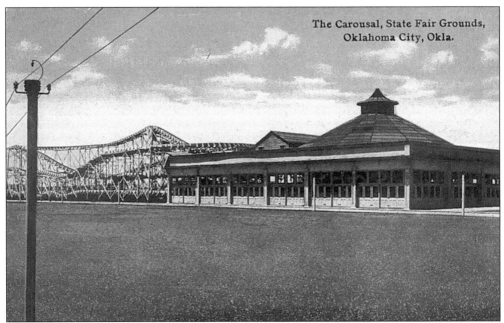

The Carousal, State Fair Grounds, Oklahoma City, Okla.

NEW RIDES. A private firm, the Oklahoma Fair Park Amusement Company, joined in Overholser's expansion and paid for three new rides: the carousel, the "Figure Eight," and "The Canals of Venice," a $12,000 indoor attraction that carried patrons by boat along a winding canal. (Griffith Archives.)

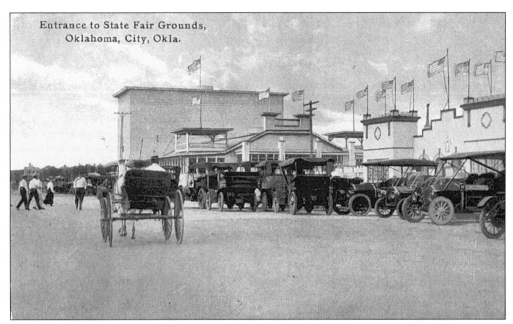

Entrance to State Fair Grounds,
Oklahoma, City, Okla.

GRAND ENTRANCE. The main gates of the state fair greeted patrons with the Exposition Building on their left. The offices were located on the upper level, while exhibit space occupied the ground floor. (Griffith Archives.)

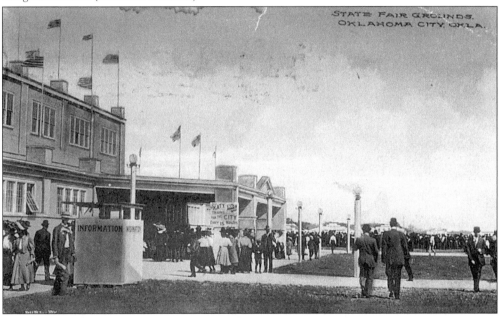

STATE FAIR GROUNDS.
OKLAHOMA CITY, OKLA.

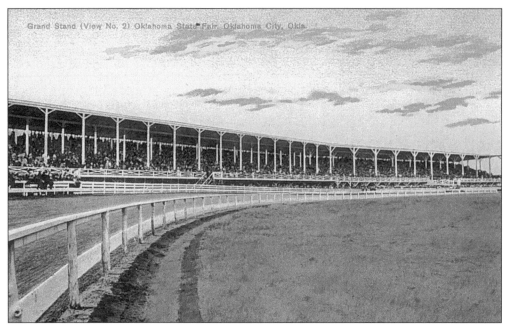

FOLLOW THE LEADERS. The State Legislature followed Governor Curse's direction and passed a bill outlawing betting on horses. The fair board banned all forms of betting in and under the grandstand during the state fair on September 24, 1913. (Griffith Archives.)

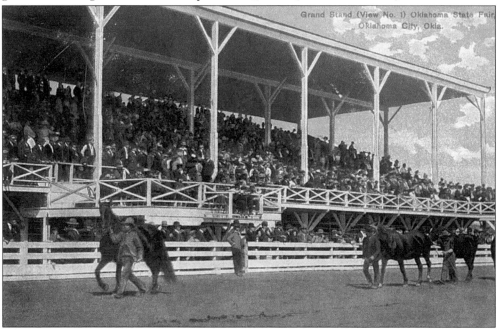

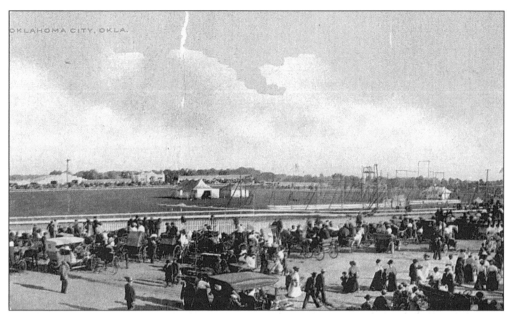

IMPROVEMENTS. Overholser and Mahan built a new paddock next to the grandstand and expanded the seating to accommodate ten thousand patrons. A new sewer system with modern toilets was also added. (Griffith Archives.)

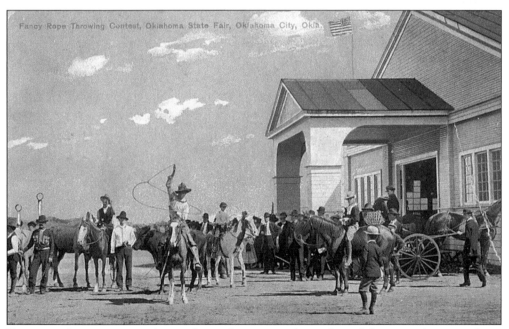

FAVORITE ATTRACTIONS. As popular as the evening fireworks and flying acrobats must have been, the featured attraction of the fair was horse racing, the rodeo, and fancy rope throwing contests. Inside the Exhibition Building, a troupe of educated Shetland ponies performed under saddle, in four, six, and ten-horse harness. (Griffith Archives.)

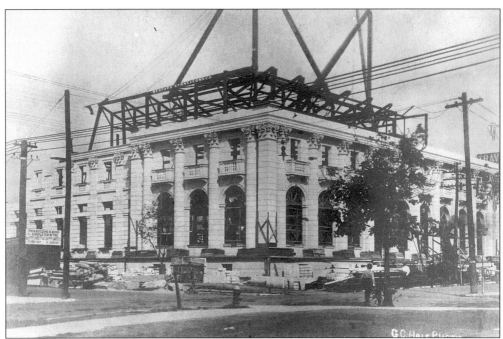

FEDERAL BUILDING, 1910. This G.C. Hale photo shows the new United States Post Office and Courthouse being constructed on the northeast corner of Third and Harvey. The building was constructed by the Bedford and Stone Construction Company of Oklahoma City. Judge John H. Cotteral and Postmaster H.G. Eastman were custodians of this new structure. (L.B. Elsey Collection of the Archives and Manuscript Division of OHS.)

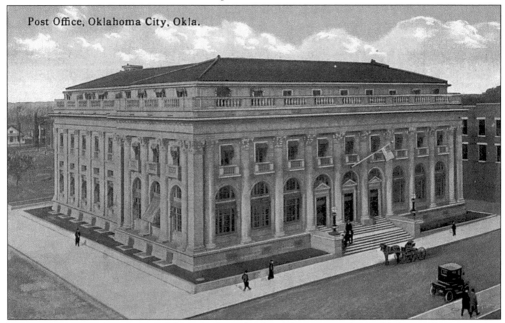

THE COMPLETED BUILDING. When W.F. and Alice Harn arrived in Oklahoma City in 1891, their first home occupied the spot where the American flag flies over the front door. (Griffith Archives.)

70

CENTRAL PRESBYTERIAN, C. 1911. Looking east on Twelfth Street one can see the bell tower of the Central Presbyterian Church, located at 230 West 12th. The Wesley Hospital is hidden behind the trees. (Griffith Archives.)

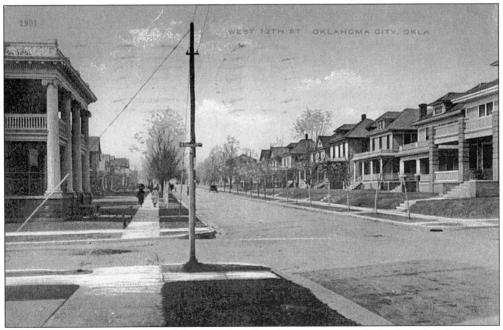

HARVEY AND TWELFTH, C. 1911. Looking the other way on Twelfth, the Wesley Hospital appears on the right. The yard in the foreground belongs to the Central Presbyterian Church. The homes on the right belonged to J.R. Tyler, J.T. Garrett, Stanley R. Bruce, and Guy V. McClure. The house at the end of the block with only the roof visible is the H.J. Akin residence, owners of the Rembrandt Studios. (Griffith Archives.)

71

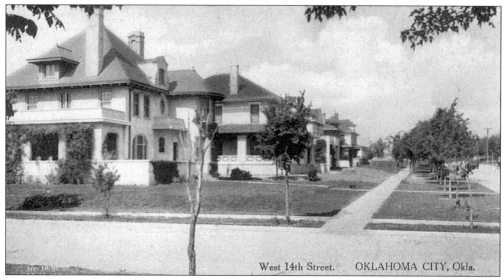

West 14th Street. OKLAHOMA CITY, Okla.

DEWEY AND FOURTEENTH. Many different architectural styles flourished north of the central business district, and this view of Fourteenth Street's south side shows two fine examples. In the 600 block off Dewey is the James F. Noble home, built in 1907. It has a combination of Victorian and Colonial Revival style. The two-story round turret with a conical roof is a common Queen Anne feature with a hint of Gothic. The home at 610 was built in 1908 for Autumn S. Connellee, owner of the Plansifter Milling Company, which produced the Plansifter Blue Ribbon Flour. (Griffith Archives.)

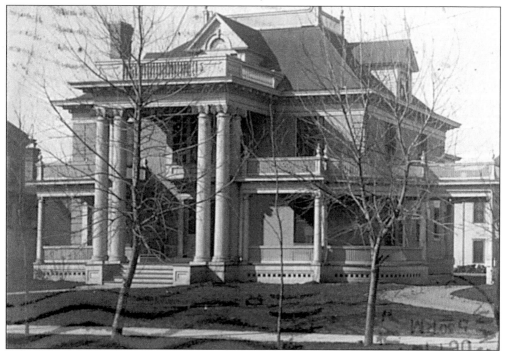

M.L. TURNER HOME. This postcard was sent to Master Budge Flynn (Olney) while in Washington D.C., by Mrs. Turner. Most early postcards only allowed for messages to be written on the front. (Streeter B. Flynn, Jr., Collection.)

72

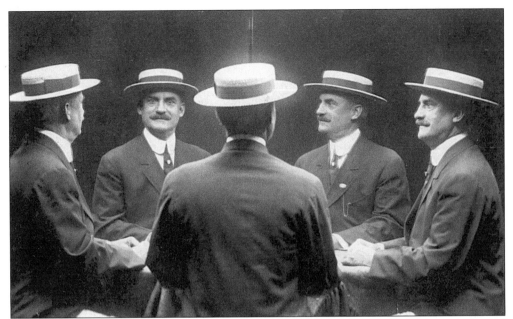

M.L. TURNER, 1911. The back of this postcard reads: "My dearest father, hamsomest, best of all men, Aug. 23, 1911." Turner was the president of Western National Bank (Griffith Archives.)*

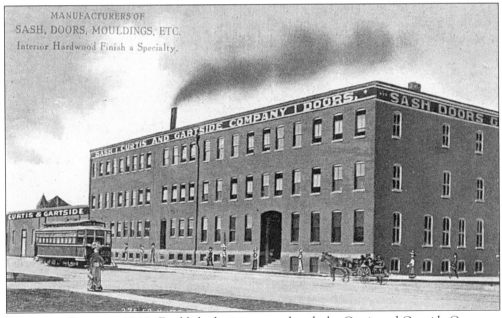

WE ARE IN RECEIPT, 1911. Established prior to statehood, the Curtis and Gartside Company was located at 701-715 West Main. C.S. Curtis served as president, and A.L. Gartside presided as secretary. This three-story brick building measured 80 by 170 feet and was equipped with facilities for the receiving, handling, and shipping of varied building materials. This postcard was sent to Mr. C.M. Mays of Sulphur, Oklahoma, to show that the company had credited his account with $17.59. (Griffith Archives.)

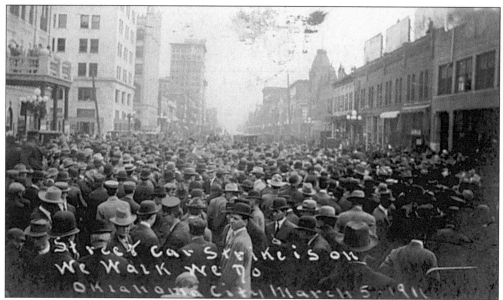

DAY ONE. The masses congregate at the Overholser Opera House on Grand Avenue March 5th waiting for city leaders to put an end to the street car strike. (Streeter B. Flynn, Jr. Collection.)

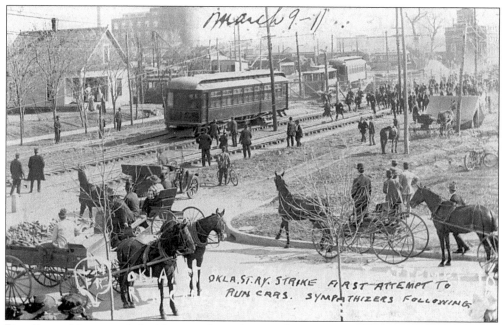

DAY FOUR. Many people had become dependent on the streetcars for transportation. The city was undergoing the transformation from horse and wagon to automobile. This group of sightseers gathered along the tracks to cheer on the non-union sympathizers and run the cars. The Oklahoma Mill & Elevator Company appears in the distance. (Griffith Archives.)*

Six

STREETCAR STRIKE

On Sunday, March 5, 1911, the Street Railway Employees Union, Local 556, led a strike against the Oklahoma Metropolitan Railway Company. The issue was not higher wages, but union recognition. Motormen were paid $2 per hour for their first year on the job. On March 5th, car number 60 left the streetcar barn with a non-union conductor and motorman in charge, but very soon afterwards, the pro-union men advanced on the car and brought it to a standstill. The union then returned the car to the barn and their attempt to organize a union was made against the majority's will. The strike began much like the one that blew up the Los Angeles Times Building.

Charles F. Colcord recalled the event in his autobiography. Everyone in the city was tired of walking and being controlled by imported thugs. Out of the three hundred employees, only 12 or 13 of the workmen had joined the union. Colcord, Judge Keaton, Streeter B. Flynn, Oscar Halsell, Oscar G. Lee, and Roy Stafford of *The Oklahoman* met with the non-union employees at the streetcar barn on McKinley Avenue while Judge Keaton held a meeting of the citizens along with Mayor Dan Lackey and Sheriff Jack Spain, Colcord, Halsell, and Lee went to the barn to reason with the union, but to no avail. They then called four hundred men from the rosters of the various city clubs to appear at the courthouse the next morning and bring their guns. The men selected had served in the Spanish-American War and the Philippine Insurrection. These men were organized into four companies of one hundred men each. The men were stationed around the city, ten men on the roofs of one-story buildings at each of the street corners. While this was going on, Kate Bernard was making an inflammatory speech on Main Street. Colcord sent Dr. Cunningham to arrest her and was then approached by Dan Perry, who asked if he could take her out of the city, in place of her going to jail. Perry was given the okay and Kate was taken out of the city.

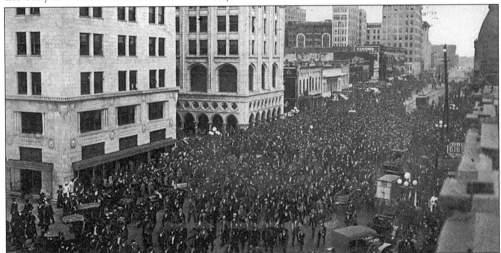

RUSH HOUR. While the streetcars were stored in the barns and along the city streets, residents were forced to walk, as driving any vehicle became impossible. This scene, taken from the roof of the Grand Avenue Hotel looking east, shows the crowds on Grand Avenue. The Colcord and Baum Buildings are on the left. (Griffith Archives.)

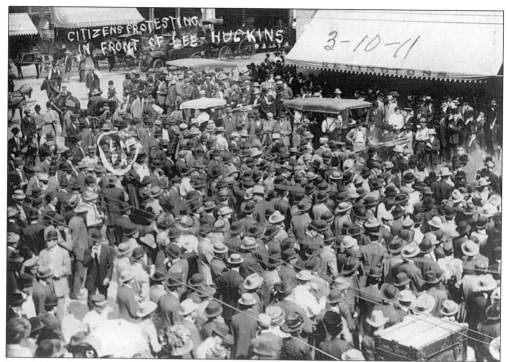

DAY FIVE, 10TH MARCH 1911. After five days of being controlled by "big city thugs," the citizens rally at the Lee-Huckins Hotel in hopes of hearing a plan to end the strike. (Griffith Archives.)*

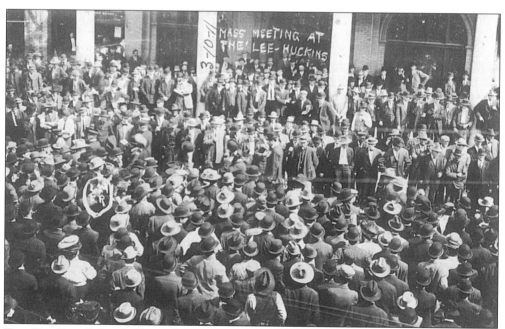

THE BIG SIX. Colcord, Flynn, Keaton, Lee, Halsell, and Stafford meet to discuss in private meetings while the crowds wait for word on Broadway. (Griffith Archives.)*

STUCK IN TRAFFIC. This couple is having a difficult time crossing Grand Avenue while the citizens of Oklahoma City use the streets for their silent protests. (Griffith Archives.)*

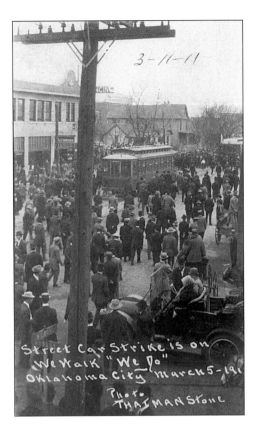

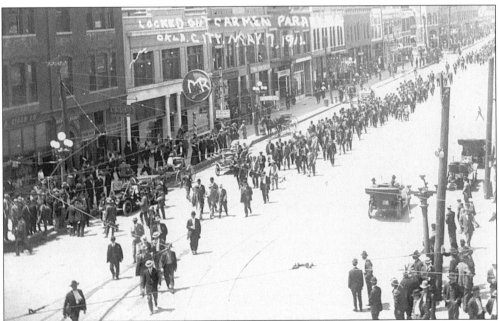

NEARLY A MONTH. The carmen of the Oklahoma Railway Company parade on Broadway Avenue on May 7th. The Batchelder Building is on the left. (Griffith Archives.)*

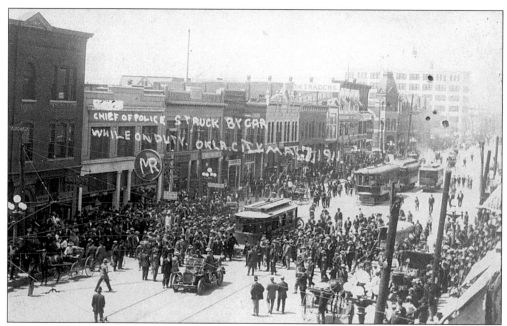

THE END. Sheriff Colcord phoned John Shartel, manager of the streetcar line, to ask him to begin rolling the stock. "How many?" asked Shartel, and Colcord answered, "All of them." During the parade, Chief of Police William Tilghman was struck by the car in this Malzman and Rehfield photo. (Griffith Archives.)*

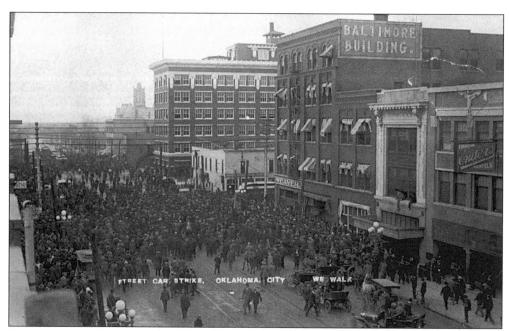

CELEBRATIONS. Colcord invited Sheriff Jack Spain and Epworth University (Oklahoma City University) President, Dr. Bradford, to ride in the lead car. This photo shows the Terminal Building on Grand. The strike was over. (Griffith Archives.)*

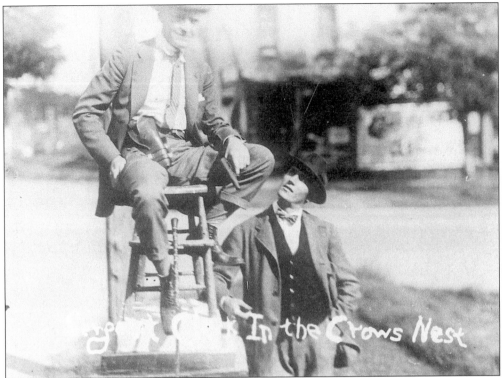

CROWS NEST. Sgt. Clark sits in the crows nest while young Streeter B. Flynn looks on. All the men recruited by the "Big Six" were armed with Winchesters, shotguns filled with buckshot, or side arms to ensure that the peace was maintained and that the union stayed out of the city. (Streeter B. Flynn, Jr. Collection.)*

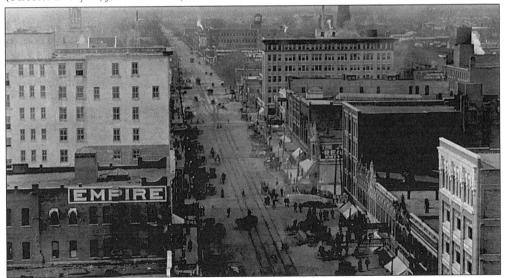

BACK TO NORMAL. In the days following the end of the strike, residents could once again ride the streetcars into the city without fear of being stranded miles from home. In this scene looking west along Main Street, one can see the tower of the old courthouse on the left. Choctaw Flour is being made in the mills on First and Francis to the right. (Griffith Archives.)

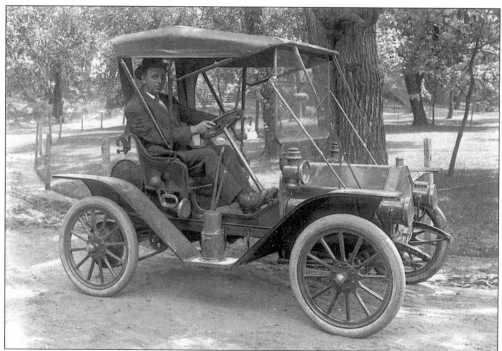

A Drive Through Wheeler Park, c. 1911. This unidentified man sits behind the wheel of a 1911 two-cylinder Model 14 Buick. Notice the chain-driven rear axle. (Griffith Archives.)*

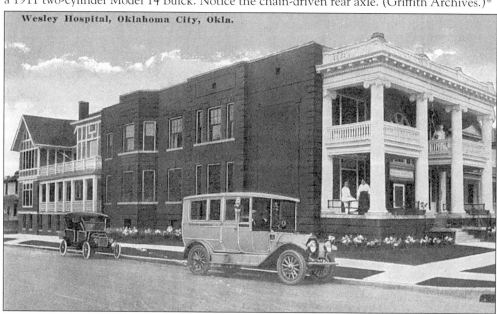

Wesley Hospital, Oklahoma City, Okla.

Wesley Hospital, December 1911. At the time, this hospital was located at Twelfth and Harvey, but it was previously on the 9^{th} floor of the Campbell building and the 11^{th} and 12^{th} floors of the Herskowitz building. The hospital boasted atmospheric purity and charged $15 a week for private wards, while private rooms ranged from $20 to $35 per week. J.G. and A.M. Street and J. M. Draper, who operated the Street and Draper Funeral Home, owned the motorized ambulance. (Griffith Archives.)

THE HEISERMAN'S, C. 1911. Edward F. and Nora E. Heiserman owned and operated a confectionery shop at 801 West California. Also pictured is their dog Chubby. (Beitman Collection of the Harn Homestead Museum.)*

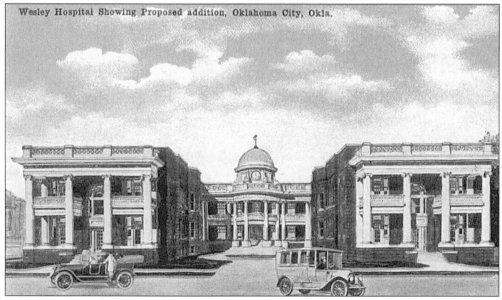

PROPOSED ADDITION, C. 1911. The Wesley Hospital had plans to expand with a twin wing to the east and administrative offices in the center, but this was not meant to be. Pictured in front of the hospital is the new motorized ambulance owned by the Street and Draper Funeral Home. (Griffith Archives.)

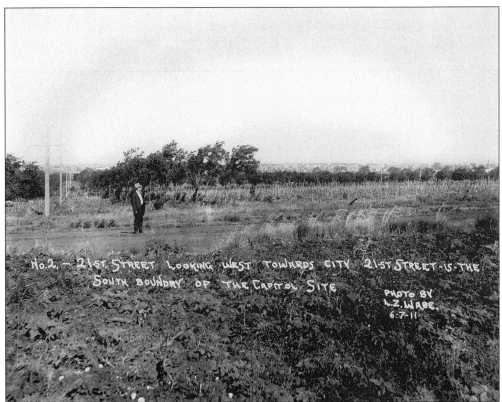

SITE OF THE FUTURE STATE CAPITOL, 1911. These two L.Z. Wade photos were taken June 7, 1911. The top photo shows William Fremont Harn as he stands looking west towards Oklahoma City on what will be the south boundary of the state capitol. The area in the background is the Maywood Addition. The lower photo shows Harn facing north with the Lincoln School in the background. The camera is on the actual center of the proposed capitol building. (Griffith Archives.)*

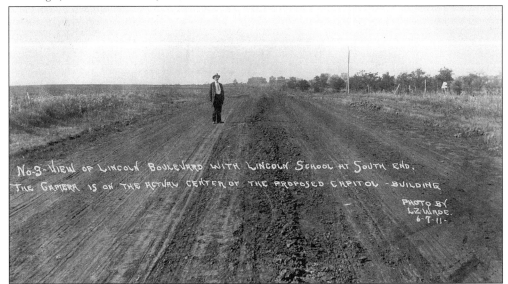

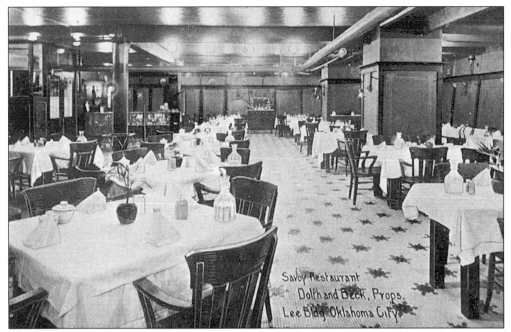

THE SAVOY, C. 1911. The popularity of elegant dining on solid wood tables and chairs with crisp white linen tablecloths and napkins, while being served by waitresses in white uniforms, flourished during the second decade of this century. The Savoy was located in the Lee Building at Main and Broadway. (Griffith Archives.)

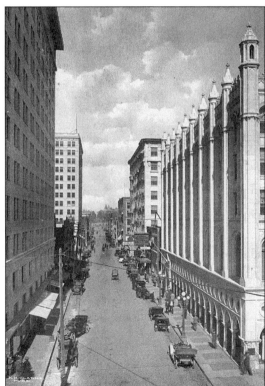

ROBINSON AVENUE, C. 1911. After the building boom of 1910, Robinson Avenue was transformed from simple two or four-story buildings to a "Canyon" of skyscrapers. The Colcord and Baum Buildings are in the foreground of this oversized postcard. (Griffith Archives.)

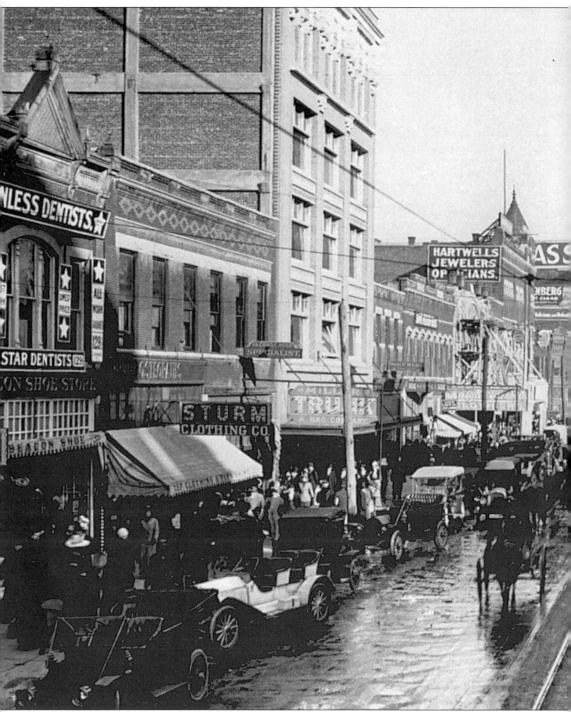

A STUDY IN URBAN DEVELOPMENT, C. 1911. You could spend hours with a magnify glass peering down the streets and into the windows of this photograph. This scene shows Main Street looking east. On the left at 129 is the Beacon Shoe Store with the Star "Painless" Dentist on the second floor. Sturm Clothing, Miller Trunk and Bag Company, Knight, Beck, & Co.

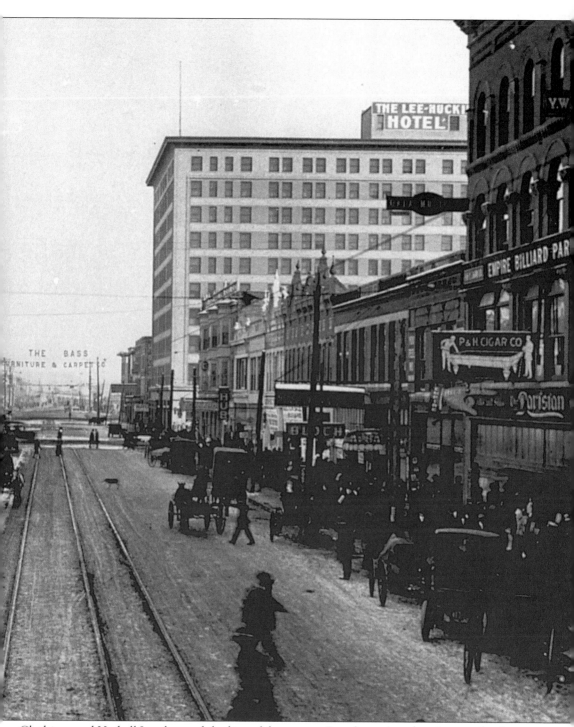

Clothiers, and Haskell Jewelers end the line of shops up to Broadway. An advertisement for the Bass Furniture and Carpet Company is strung across the thoroughfare. The Lee-Huckins Hotel and YWCA are clearly visible on the right. (Griffith Archives.)*

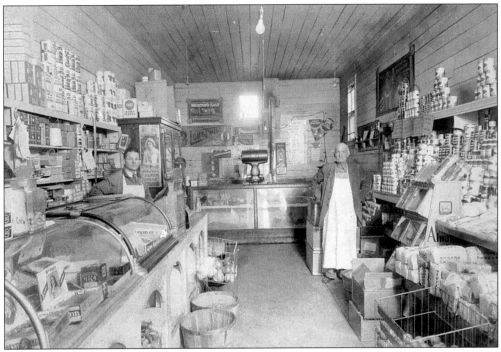

A Typical Grocery, c. 1911. The only description of this photograph is the one you create yourself. The two men are unidentified, as well as the location of this small grocery. The only identifying mark on the back reads, "South Oklahoma City." (Griffith Archives.)*

First Lutheran, 1912. This example of restrained Gothic architecture stands on the northeast corner of Twelfth and Robinson. The First Lutheran Church congregation dedicated this structure on June 30, 1912. It was designed by architects Van Slyke and Woodruff at a cost of $51,000. A sealed cooper time capsule was placed in the basement and will be opened in 2013. (Griffith Archives.)

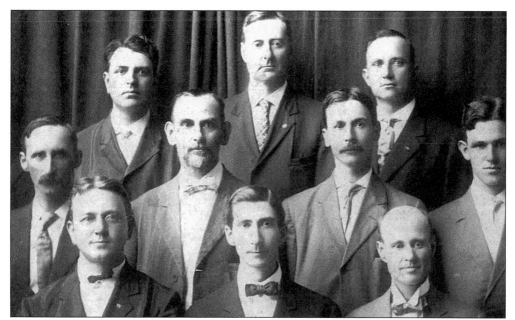

BOARD OF DIRECTORS, 1912. On December 27, 1900, seven men, four from Ft. Smith, Arkansas, and three from Oklahoma City, incorporated the Armstrong Hardware Company, formed "to operate and carry on a wholesale and retail hardware business and such other lines of goods, wares and merchandise as may be appurtenant and appropriate to such business." On January 14, 1905, the name was changed to Oklahoma City Hardware Company. In 1912, a four-story and full basement building was erected at 25 East California at a cost of $61,000. The first photo shows S.E. Clarkson, president, and his two brother-in-laws, A.W. Boyd and W.H. Vick. along with the company's sales force. The second photo shows Mr. Clarksons, standing in the back, and his wife Laura, outside their home at 421 East 12th Street, in the old Maywood addition. Mr. Rowland was an early day attorney and oilman. Rowland and William Skirvin worked together in the Oklahoma Oil and Refining Co. They sought oil in the Burkburnett, Texas oil field. A few years after Mr. Rowland's death in 1912, a producing oil well was drilled in the backyard. (Rowland A. Clarkson Collection, Greeneville, Tennessee.)*

WHEN YOU CARE ENOUGH, 1912. Novelty postcards were available for any occasion when the sender couldn't write what he wanted to say. The back of this card was postmarked 10 p.m. on July 17, 1913, and reads; Dear Sister: Rec'd your letters but did not get the last one until I got back Mon. Will write a letter soon. B.B." (Griffith Archives.)*

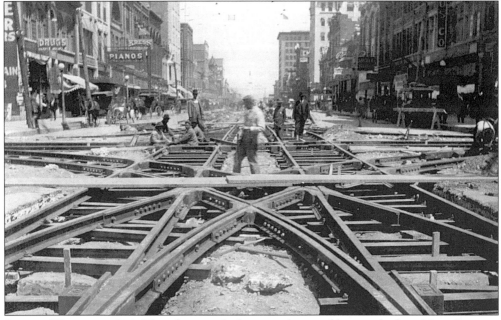

SPECIAL WORK, C. 1912. This photograph shows workmen adding track along Main Street at Harvey. The detail of how the tracks were installed is incredible. (Griffith Archives.)

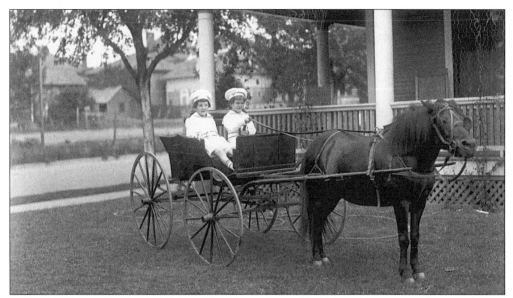

THE AKINS FAMILY. Elmer and Donald Akin are dressed in sailor suits as they sit in their buggy. The Akins lived at 329 West 12th Street and Mr. Akin owned the Rembrandt Studios on Mains Street. The bottom photograph shows Herbert J. and Bertha P. Akin along with Elmer and Donald a few years later. (Akin Family Collection of the Harn Homestead and 1889ER Museum, held by the Archives and Manuscripts Division of OHS.)*

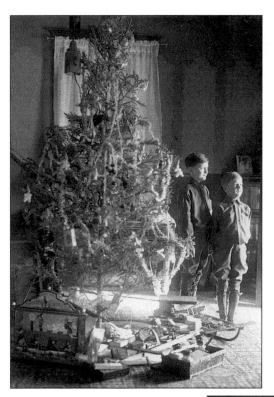

CHRISTMAS 1917. Some years later, the boys were photographed in soldier uniforms. The front door was opened to allow for lighting. Note the electric cord running from the ceiling light fixture to the Christmas tree. (Akin Family Collection of the Harn Homestead and 1889ER Museum, held by the Archives and Manuscripts Division of OHS.)*

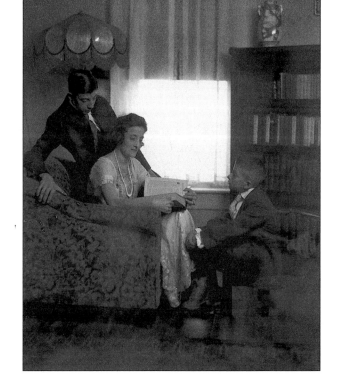

ADORING SONS, C. 1922. Elmer and Donald gaze upon their mother as she reads in the living room of their home on Twelfth Street. (Akin Family Collection of the Harn Homestead and 1889ER Museum, held by the Archives and Manuscripts Division of OHS.)*

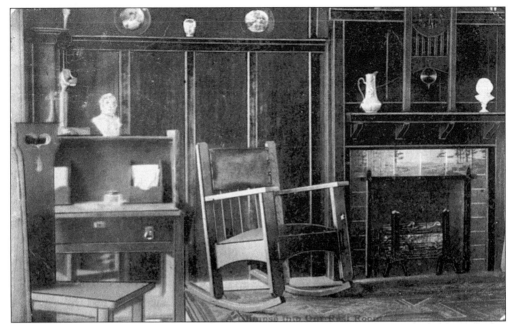

A PUBLIC RESTROOM. The words, "A glimpse into our Rest Room, Sidney L. Brock Dry Goods Co., Oklahoma City" are barely visible. Notice the candlestick phone, fireplace, rocking chair, writing desk with pen and ink and paper—all in a public restroom. The dry goods store was located at 213-215 West Main. Mr. Brock operated his store from 1906 until 1915, at which time he sold it to the John A. Brown Company. (Griffith Archives.)

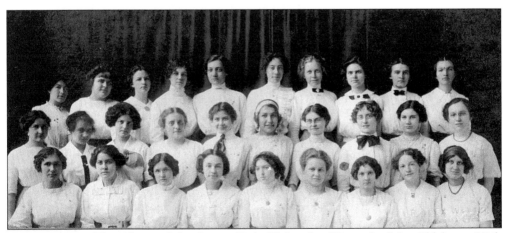

PARTIA, 1912. This photo of the Senior Girls Club, a.k.a "Partia," of the Oklahoma High School was taken on May 14, 1912. (Griffith Archives.)*

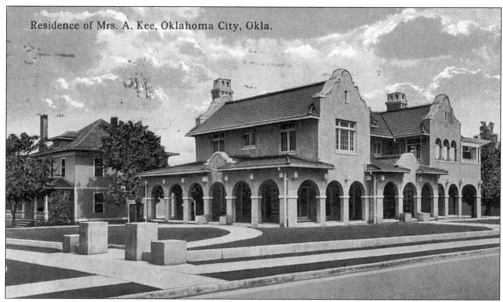

Residence of Mrs. A. Kee, Oklahoma City, Okla.

KEY, NOT KEE, 1913. This misspelled postcard identifies this as the residence of Mrs. A. Kee at North Hudson. Mr. Alanzo Kee began building this home in 1913. He sold the almost-completed dwelling to General Roy Hoffman, who furnished it and moved in sometime during 1915. Henry C. Pelton of New York City designed this Spanish-style residence. (Griffith Archives.)

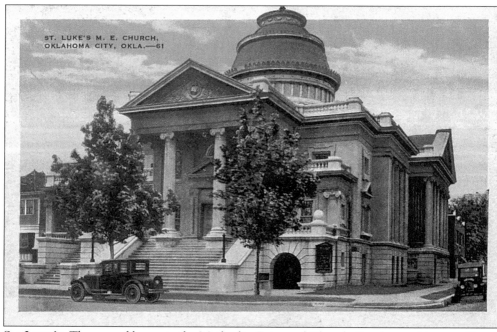

ST. LUKE'S M. E. CHURCH,
OKLAHOMA CITY, OKLA.—61

ST. LUKE'S. The second home to the Methodist Episcopal Church, South was this magnificent structure located on the northwest corner of Eighth and Robinson Avenue. The congregation stayed in this structure until they moved, in the late 50s, to their new home at 15th and Robinson. (Griffith Archives.)

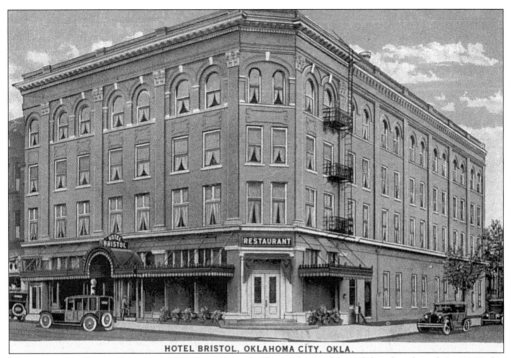

HOTEL BRISTOL, OKLAHOMA CITY, OKLA.

MYSTERIOUS SIXTH FLOOR, 1913. Dr. Threadgill was the builder of this fine hotel. In 1913, he sold the five-story building and it was renamed the Hotel Bristol. It never had a sixth floor, as this hotel envelope indicates. (Griffith Archives.)

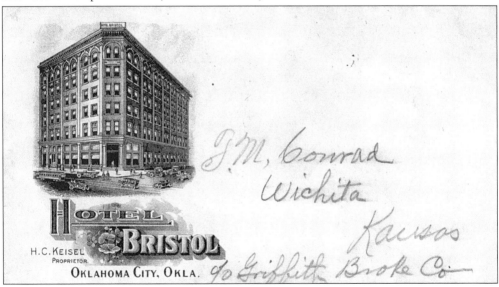

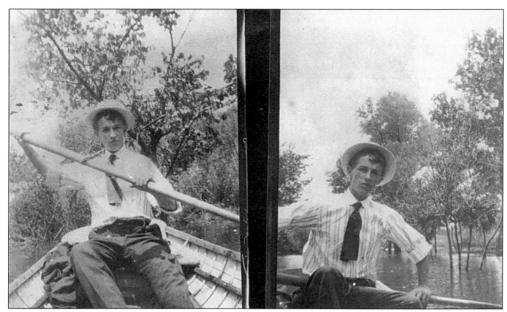

ROW, ROW, ROW YOUR BOAT, 1914. These two small photographs show Streeter B. Flynn on the lake at the Oklahoma City Golf and Country Club at West 39th and Western. (Streeter B. Flynn, Jr. Collection.)*

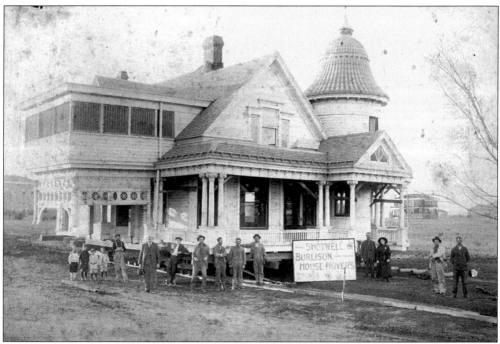

LOCK, STOCK, AND BARREL, 1914. This R.A. Ewing photograph shows the Shotwell and Burlison House Movers doing what they do best—moving houses. This home was probably located in the Putnam Heights area. (Griffith Archives.)*

I'M READY FOR MY CLOSE UP, 1915. Harriett Colcord wore this ball gown at the 1889ERS Festival in 1915, where she was crowned "Queen" by Governor Robert L. Williams. She also wore the gown to the Winter Carnival in New York City in 1915, and to the 1916 Mardi Gras Parade in New Orleans. After movie producer Cecil B. DeMille saw the gown in publicity photographs of the parade, she rented it for Gloria Swanson to wear in one of his epic films, which has since been lost to time. (Archives and Manuscripts Division of OHS.)

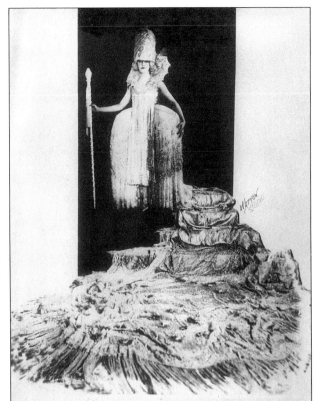

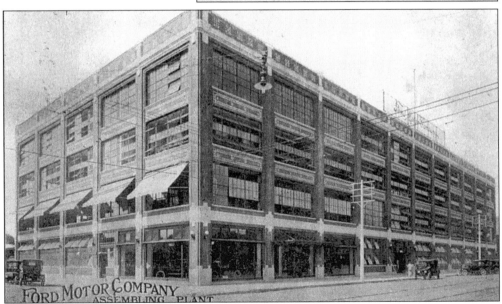

FORD MOTOR COMPANY, 1915. The most important advance in the Oklahoma City automobile industry occurred in 1915 when Henry Ford constructed a Model T assembly plant on West Main Street. Within a year, the plant turned out 244 autos each day. The county assessor announced that for the first time cars outnumbered horses in Oklahoma City, 1900 to 1353. (Griffith Archives.)

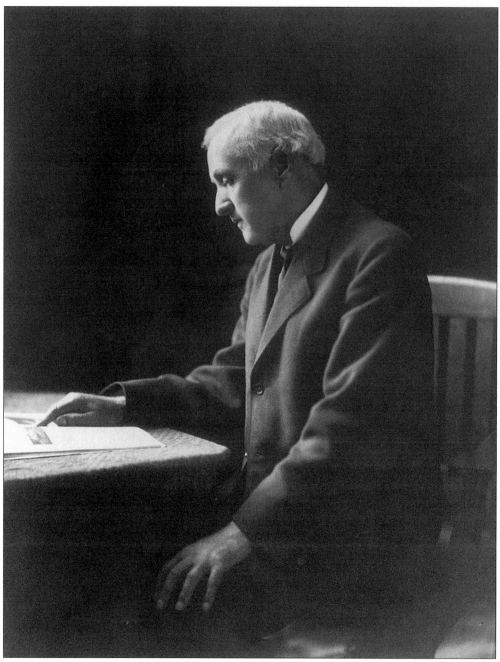

PAPA HENRY, 1912. The May 1912 issue of *The Oklahoma Magazine* reproduced this photograph of Henry Overholser. Editor William Taylor wrote of Henry's many accomplishments in an article entitled, "Henry Overholser—Oklahoma's Grand Old Man." (Overholser Collection of OHS.)

Seven

THE FATHER OF OKLAHOMA CITY

HENRY SAMUEL OVERHOLSER

Henry Overholser was 43 when he made the Run of 1889 into Oklahoma Station. Over the next 26 years, he would be instrumental in making Oklahoma City grow from a "tent city" of 10,000 into a modern metropolis. Many of his accomplishments were never recorded but those that were proved him worthy of his title, the Father of Oklahoma City.

At Overholser's funeral, Rev. VanHorn of the First Christian Church read from Second Corinthians 4:17 and 18. Police and firemen led the escort from the Overholser residence to Fairlawn Cemetery. Pallbearers were William F. Petee, Anton H. Classen, J.H. Everest, A.H. Cooke, Judge B.F. Burwell, John Shartel, John Shields, Elmer Brown, and J.F. Warren.

For an hour, while the sad rites were in program, businesses closed their doors and citizens suspended social and business duties. All the flags in the city hung at half-mast, while every outward sign expressed the city's deep grief in the death of its most honored citizen.

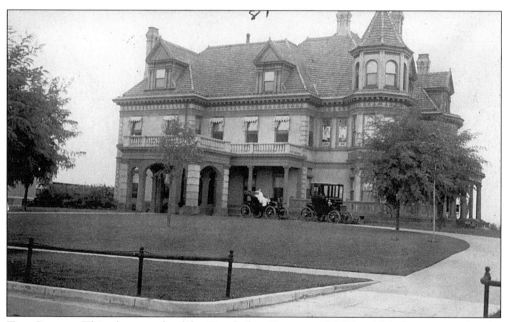

THE CASTLE. This photograph of the Overholser Home at 405 West 15th Street was taken by young Streeter Flynn. Mrs. Henry (Anna) Overholser poses in her automobile. An electric car is also pictured, as well as a wheelchair, which is barely visible in the yard on the right. Henry Overholser had a stroke sometime in 1912. (Streeter B. Flynn, Jr. Collection.)*

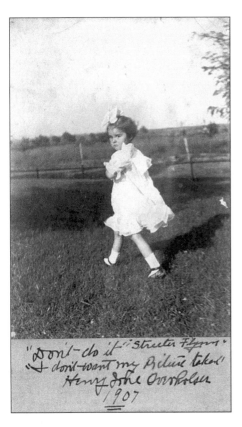

BIRTHDAY PARTY, 1907. Henry Ione Overholser was the only surviving child of Henry and Anna. Young Streeter Flynn took these two photos in April 1907. The first caption reads, "Don't do it Streeter Flynn, I don't want my Picture taken." The next photo shows Henry Ione playing in the sand with Fisher Ames. In the 1921-22 Oklahoma High School yearbook, Fisher was recorded as a charter member of the Red Shirt Club. When a member graduated, he was to pick out the junior of senior who was to take his place the following year. Officers were Fisher Ames, president; William Dempsey, vice-president; Dorset Carter, treasurer; and yell leader, George Guthrie. The purpose of the club was to make the football games livelier and promote school spirit. (Streeter B. Flynn, Jr. Collection, Oklahoma City.)

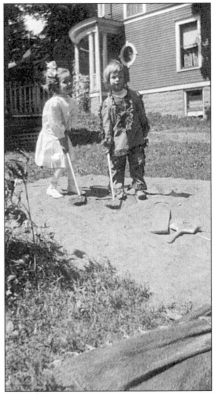

THE FAMILY, C. 1915. This scene shows a tired Henry with his devoted wife Anna and their daughter Henry Ione. (Overholser Collection of OHS.)*

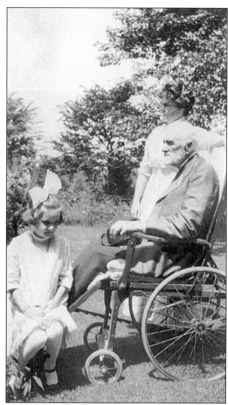

THE OVERHOLSER TOMB, 1915. The headline of the August 25th issue of *The Daily Oklahoman* read, "Strong, kindly hands that lifted the arm and patted the shoulders of Oklahoma City are folded—Henry Overholser has passed." The *Oklahoma City Times* stated, "all that is mortal of the late Henry Overholser was laid gently to rest in beautiful Fairlawn Cemetery at 4:30 o'clock Friday afternoon following the funeral service at the residence, 405 W. 15th Street." (Overholser Collection of OHS.)*

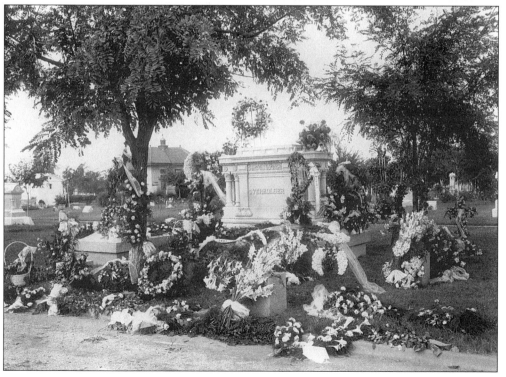

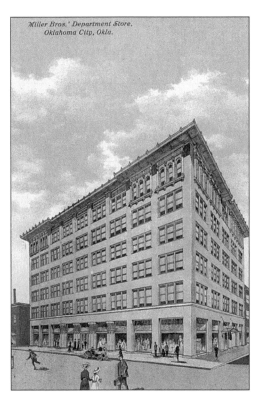

Miller Bros.' Department Store. Oklahoma City, Okla.

GOODHOLM BUILDING, C. 1915. Pictured here is the old Goodholm Building, which was located on the northeast corner of Grand and Harvey. Miller Bros. Dry Goods was just across the street to the south. Sometime in 1915, the building was renamed the Baltimore Building and the Miller Brothers moved in. (Griffith Archives.)

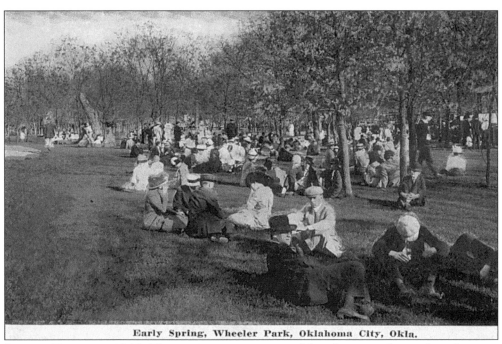

Early Spring, Wheeler Park, Oklahoma City, Okla.

SUNDAY PICNIC, C. 1915. This was a common postcard found at most dry goods and variety shops across the city. This scene shows a large crowd out for a picnic in Wheeler Park. (Griffith Archives.)

CRUSIN' THE STREETS, C. 1917. These fellows out for a Sunday drive in their buggy are Claude Coy, Willard Fisher, and Clyde Chips. Automobiles were affordable by 1917, but these guys chose to save on gas and take the mule out for some exercise. (Griffith Archives.)*

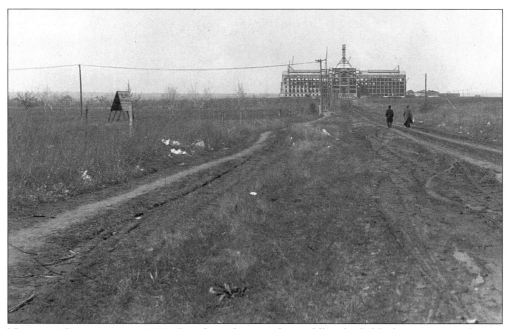

NEARING COMPLETION, 1917. Standing alone in the middle of a field, the state capitol nears completion. Looking to the north, William Fremont Harn stands in the middle of what will later become Lincoln Boulevard. Harn purchased a 160-acre homestead in 1891 and gave 20 acres for the placement of the capitol, as did J.J. Culbertson. The capitol sits square in the middle. (Griffith Archives.)

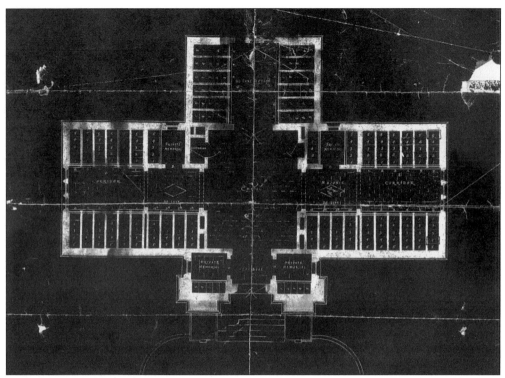

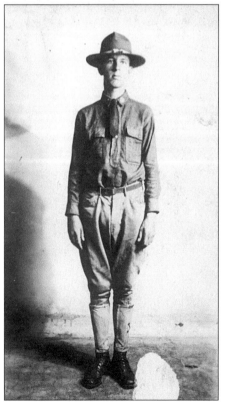

ROSE HILL MAUSOLEUM, 1917. These old blueprints were salvaged out of a trash dumpster in 1993. The first mausoleum built at Rose Hill faced southeast, in the direction of the state capitol. Anton and Ella Classen are entombed in this imposing structure. (Griffith Archives.)*

A PROUD SON, 1918. Mr. and Mrs. D.S. Phillips must have been very proud when they received this postcard of their son Ward. At the age of 17, he had enlisted on February 23, 1918, into Company M, 19th Infantry at Camp Travis. (Archives and Manuscripts Division, OHS.)*

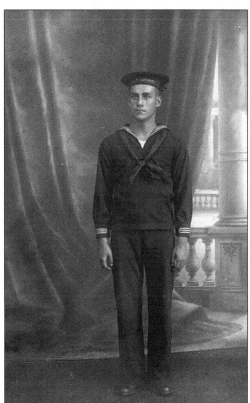

FLYNN BROTHERS GO TO WAR, 1918.
These two postcards show Olney Flynn (right), who was stationed on the *USS Harvard*, while Streeter B. Flynn remained in Washington, D.C. as a paymaster. (Streeter B. Flynn, Jr. Collection.)*

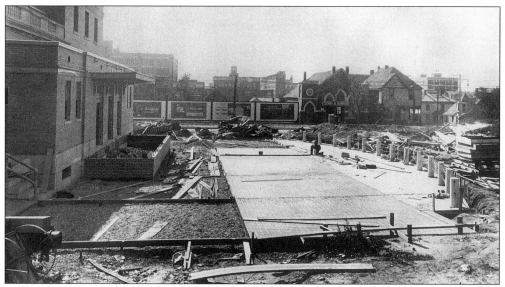

PHASE TWO, 1918. By 1918, the Federal Building was expanded to occupy the entire south end of Third Street to Robinson. This photograph shows workmen laying the tile floor. Looking towards Third, many buildings can be identified. In the background facing straight on, is the Alexander Drug Company at 226-32 West First Street, and the OK Transfer and Storage Building is on the far right at 326-30. The abandoned church building once held the faithful First Lutheran congregation, but is now the home to Temple Garage at 226-28. (Archives and Manuscripts Division of OHS.)*

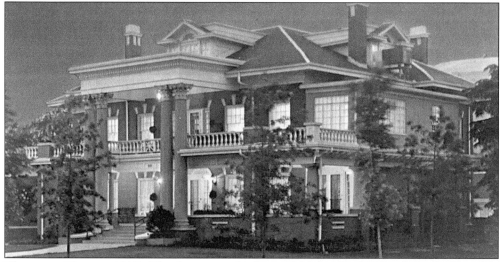

HERITAGE HOUSE, 1917. This home was built in 1917 for the family of Frank L. Mulky, president of the Oil and Mineral Development Company, and the Producers Oil Exchange. The home was later sold to Justice and Mrs. Robert A. Hefner in 1927. Today this mansion at 14th and Robinson is home to the Oklahoma Heritage Association (Griffith Archives.)*

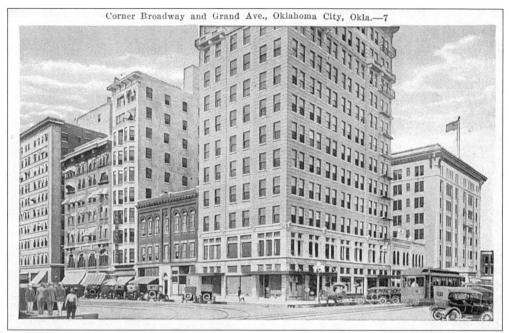

EVERYTHING'S UP TO DATE IN OKLAHOMA CITY. This postcard scene shows a third generation of buildings from an artists' perspective. From left to right are the Lee-Huckins Hotel and Annex Building and the Campbell Building, designed by Frank D. Hyde. Next door is the Wells Fargo Co., the Herskowitz Building, and around the corner with the flag, is the Hotel Kingkade and Hotel Lawrence. None of these buildings remains in existence today. (Griffith Archives.)

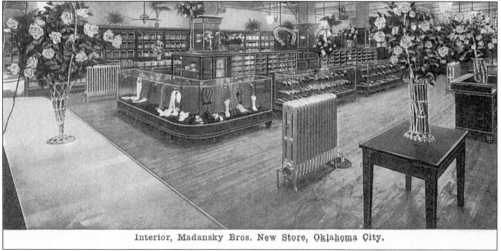

Interior, Madansky Bros. New Store, Oklahoma City.

MAY BROTHERS, C. 1920. Paul and Benjamin Madansky owned men's clothing stores in Tulsa, Bartlesville, and Oklahoma City. This view shows their new store at 225-227 West Main. Following World War I, there was some ill-will against those with foreign sounding names. The Ku Klux Klan became more visible, and there was a general hatred to anyone not born in America. The Madanskys emigrated from Russia and probably had a greater appreciation for their freedom than those who were born on American soil. The brothers "Americanized" their name to "May" in March of 1921. (Griffith Archives.)

FATHER SHADID, C. 1920. The first immigrants in the Twin Territories were Joe Abraham of Bristow (Indian Territory) and Eidal Khouri of Oklahoma City (Oklahoma Territory). There was no mention of any Syrian-Lebanese in the 1890 census, but by 1900 the census listed 103 persons of Syrian descent—73 in Oklahoma Territory and 33 in Indian Territory. Many of these early immigrants to Oklahoma City were from the village of Jadiadet Marj'uyum in what is now southeastern Lebanon. In 1918 these families decided that they should have a church of their own. In October 1920, Father Shuksllah Shadid of Marj'uyum arrived, and for the next eleven years conducted Divine Liturgy in Arabic at his home. (St. Elijah Antiochian Orthodox Christian Church Archives, Oklahoma City.)*

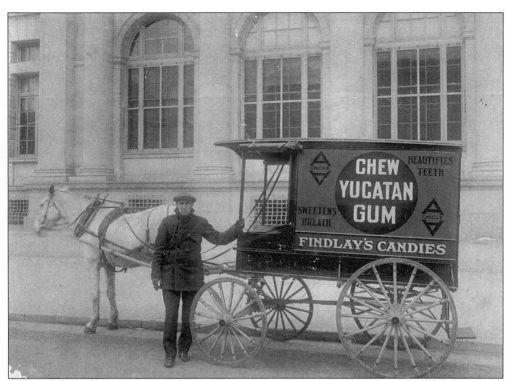

CHEW YUCATAN GUM, C. 1920. With the Federal Building completed, this unidentified delivery driver poses with horse and livery for Findlay's Candies. Findlay's was an offshoot of the Metropolitan Candy Company at 719-23 West California, which was established in 1911 by John T. Findlay, George R. Stephens, and R.P. Schuster. (Griffith Archives.)*

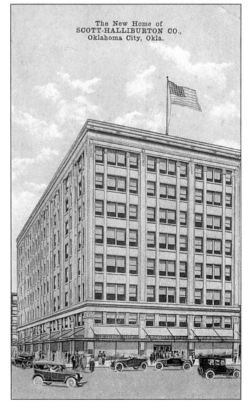

A NEW HOME, 1920. In 1898, Halliburton's began serving the citizens of Oklahoma City as a dry goods store operated by R.B. Halliburton. This structure was constructed in 1920 at 327 West Main. Through the years, Halliburton has had several partners. The store was known as Scott-Halliburton, McEwen-Halliburton, and Gloyd-Halliburton. A leading department store for several decades, it fell victim to suburban shopping and closed its doors in 1960. The building stood empty for many years and was finally demolished on April 17, 1977. (Griffith Archives.)

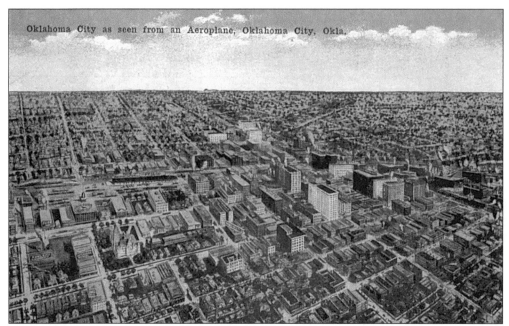

EARLY AERIAL, C. 1920. Looking to the northeast, this view of metropolitan Oklahoma City was taken from an airplane. Many landmarks are visible and some are even labeled, probably by the artist of this postcard. You may need a magnifying glass to identify them. (Griffith Archives.)

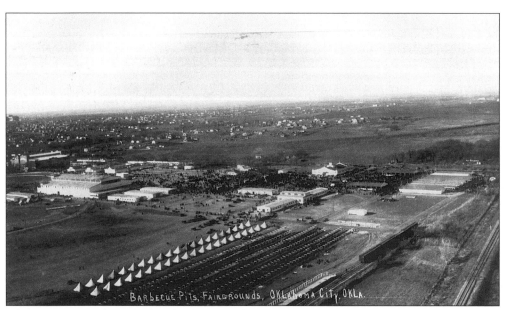

BBQ, C. 1922. What a feed at the fairgrounds, east of downtown. Note the capitol building in the upper left. (Fort Sill Collection of the Archives and Manuscripts Division of OHS.)

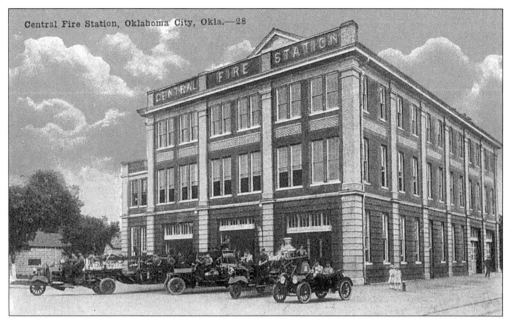

CENTRAL FIRE DEPARTMENT, C. 1922. Gone are the days when Oklahoma City was the only city in the world that could present a precision drill maneuver showing how the horses were harnessed and unharnessed. As the city grew, stations and equipment were added to ensure public safety. Central was located at 426-30 West California with Fire Chief A.G. Meyes and assistant John L. Lynn. in charge. (Griffith Archives.)

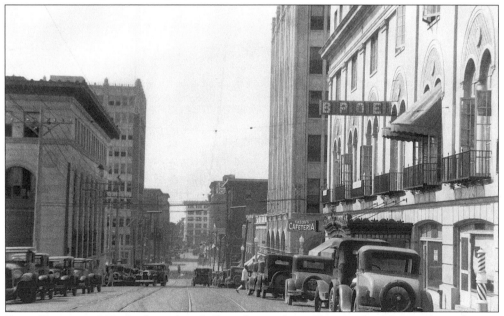

BLUE HILL, C. 1923. Looking downhill to the south on Harvey, this Meyers photo shows a typical day in Oklahoma City. On the left is the Federal Reserve Bank with the Cotton Exchange Building in the background. The B.P.O.E. Lodge is on the right, with the Oklahoma Gas & Electric Building across the street to the south. The white structure in the far background is the Mellon Dry Goods. (Griffith Archives.)*

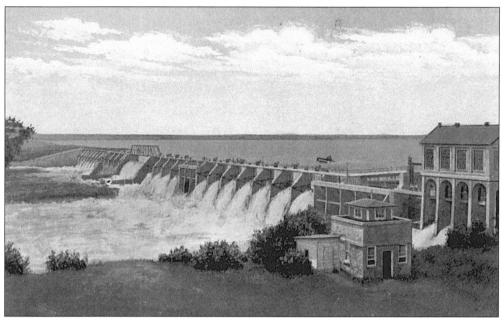

LAKE OVERHOLSER, 1915. A new city reservoir site was chosen by Henry Overholser sometime in the early 1910s. This postcard shows the reservoir after its completion in 1915. (Griffith Archives.)

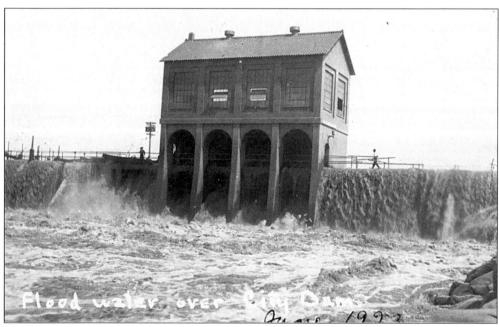

THE RAINS CAME, 1923. The rains had swollen the reservoir until the city dam could not contain the water, so the flood gates were opened to keep the dam from breaking. Workers walk across the dam at the power house. (Griffith Archives.)*

Eight
THE GREAT FLOOD

The old riverbed came down the south side of Main Street, crossed onto Hudson, and then crossed the south side of Main just east of Robinson. The river then angled to Grand Avenue about to the corner of Broadway and then east under what is now the old Liberty Tower (BankOne), following east to the Burlington Northern & Santa Fe Railroad tracks, into the old warehouse district (Bricktown), and then southeast into the present bed of the river. With that information, one might wonder why the early settlers just didn't move north a few yards to Blue Hill (St. Joseph's Old Cathedral and the A.P. Murrah Bomb Site) and start building the future capitol city. Instead, the city fathers decided to re-route the flow of the North Canadian River to what we have today, taking their chances on any flooding in the low areas. They hadn't anticipated a major flood. The North Canadian River bed is primarily sand, so it is quickly absorbed when the river rises. In 1923, however, this was not the case, as the river crested and flooded the central business district. The following photographs document the devastation of the Great Flood of 1923.

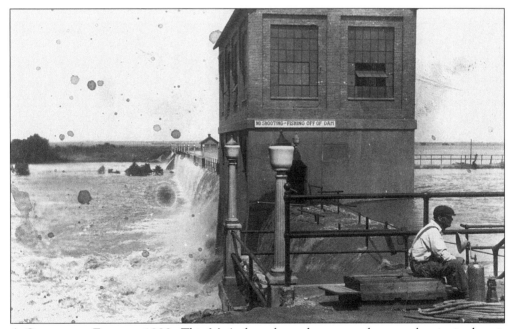

A COMEDY OF ERRORS, 1923. This McArthur photo shows a workman as he sits in despair while millions of gallons of water cascade over the dam into the swollen North Canadian River. Note the sign on the powerhouse, "No Shooting or Fishing off of the Dam." (Craig Collection of the Archives and Manuscripts Division of OHS.)*

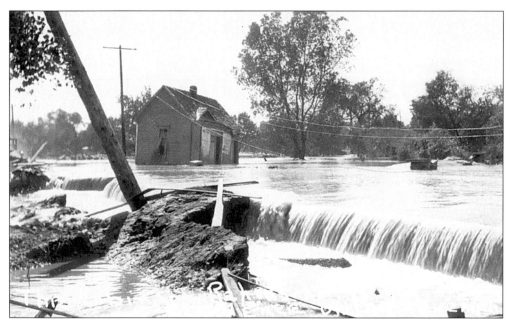

THE ROBINSON RAPIDS, 1923. This McArthur photograph shows this home still sitting on the flooded pavement along South Robinson Avenue. A message on the back of this postcard reads, "I walked along here the other day and peeped in this house, still perched upon the pavement of South Robinson. The water is now only about three ft. lower." No date was given. (Griffith Archives.)*

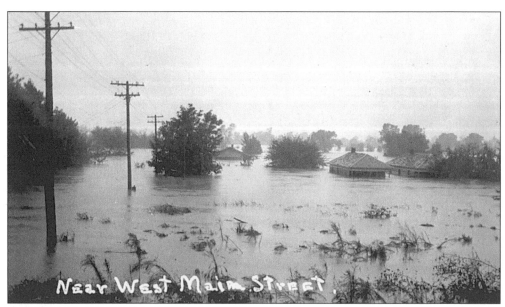

MAIN STREET, 1923. Photographer McArthur documented the devastation after the rains had ceased. This scene shows Main Street looking west near May Avenue. The same person who inscribed the last photograph continues on this postcards, "I drove out West Main and saw all this. The water being right up to the pavement." (Griffith Archives.)*

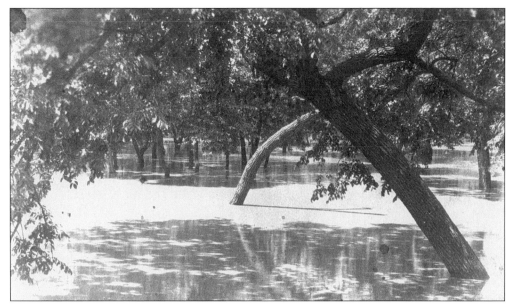

WHEELER PARK, 1923. This is what was left of Wheeler Park and the city zoo after the flood. Many of the animals lost their lives. This photograph was taken on June 8th. (Craig Collection of the Archives and Manuscripts Division of OHS.)

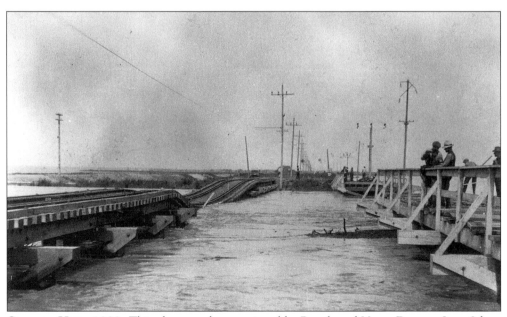

CAPITOL HILL, 1923. This photograph was printed by Roach and Veazy Drug on June 8th at the interurban and wagon bridge on 39th Street and South Robinson. (Archives & Manuscripts Division of OHS.)*

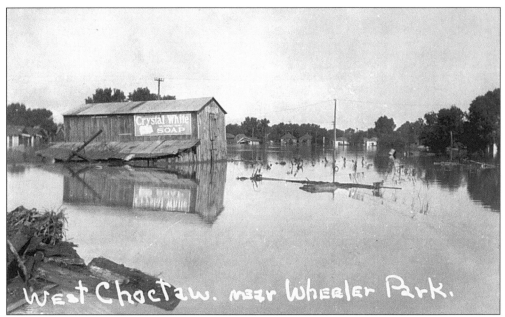

CRYSTAL WHITE, "THE PERFECT FAMILY SOAP," 1923. Only the upper level of this barn can be seen on flooded Choctaw Avenue in South Oklahoma City. This location is south of the North Canadian River, near Wheeler Park and west of Riverside School. (Griffith Archives.)*

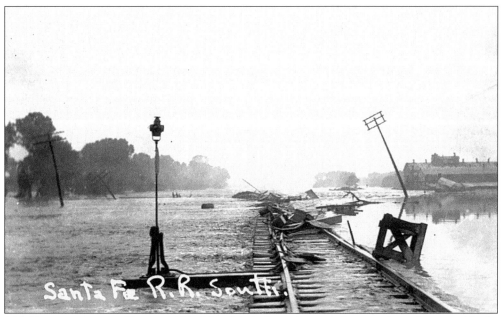

132 POUNDS TO THE YARD, 1923. This McArthur photograph was taken about six blocks south of the depot and shows how the flood waters twisted these 132-pound railroad tracks. Each section of rail is about eight feet long. (Grffith Archives.)*

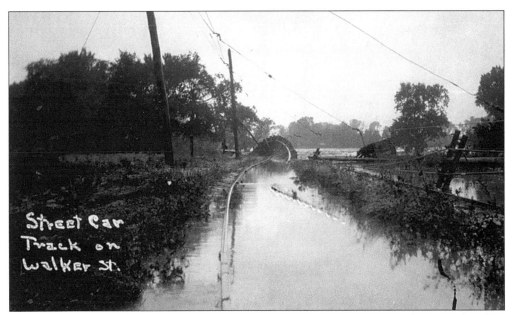

LIGHT RAIL AT 80 POUNDS, 1923. Another McArthur photograph shows the interurban line along Walker Street. A description on the back reads, "Notice the tracks standing straight up. This is where the track leaves Walker Street to cross the river and bottoms over to Capitol Hill. The Interurban goes over this to Norman. It is possibly 5 or 6 blocks from Riverside School. Exchange Avenue had been opened up and the Interurbans go around thru Packingtown." (Griffith Archives.)*

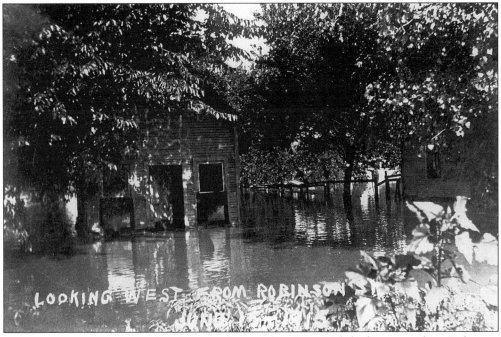

SOUTH ROBINSON, 1923. This photograph was taken June 15th looking west from Robinson Avenue at a flooded residential area. (Archives and Manuscripts Division of OHS.)

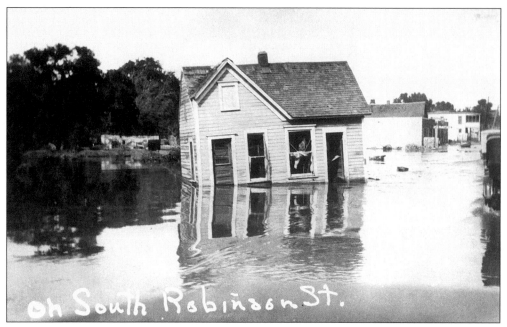

On South Robinson St.

INTO SOUTH TOWN, 1923. Following the last photograph north, one would come into the business district of South Oklahoma City. This home has been relocated by the flood waters. Note the automobiles on the right of the photo. (Craig Collection of the Archives and Manuscripts Division of OHS.)

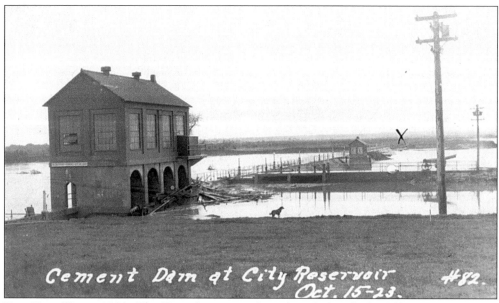

Cement Dam at City Reservoir
Oct. 15-23. #82.

THE DAM HELD, 1923. The X on this postcards is identified with the following inscription, "This shows height of water before the bank of the reservoir gave way at midnight—X. This stream in front is main bed of river. The water back is city reservoir or lake." (Griffith Archives.)

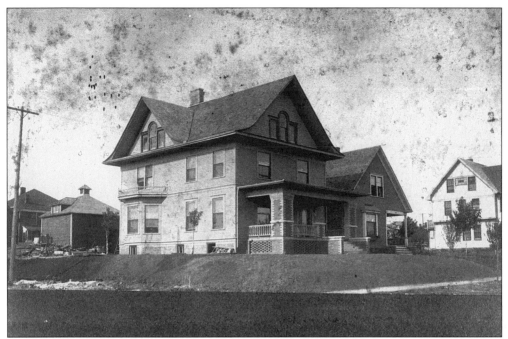

W.O. Church Home, c. 1925. This magnificent three-story home was located on Seventeenth Street and belonged to William and Jeamey Church, owners of the Church Feed Company. (W.O. Church Collection of the Archives and Manuscripts Division of OHS.)*

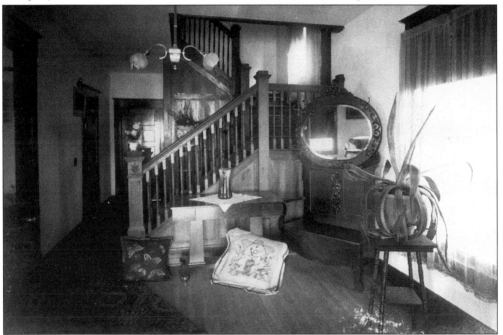

Entry Hall. The interior was constructed of white oak. This Plew photograph shows a view of the entry hall leading into the formal parlor. Although these people grew up during the Victorian Era, their home was sparsely furnished, which is indicative of the Edwardian and later eras. (W.O. Church Collection of the Archives and Manuscripts Division of OHS.)*

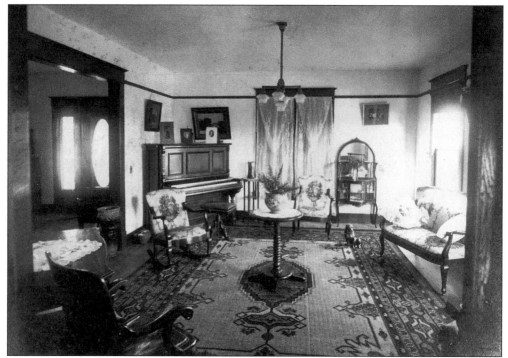

FORMAL PARLOR. The Church home had both gas and electric convenience. Although not overly elaborate, the formal parlor is quite functional. Pictures hang from the railings and the dog sits for "That Man Stone" as he captures this small piece of history. (W.O. Church Collection of the Archives and Manuscripts Division of OHS.)*

GENTLEMEN'S ROOM. While the ladies would be entertained in the front parlor, the gentlemen went into the library where cigars and brandy would be served. Dark wallpaper and wall-to-wall carpets covered the room. (W.O. Church Collection of the Archives and Manuscripts Division of OHS.)*

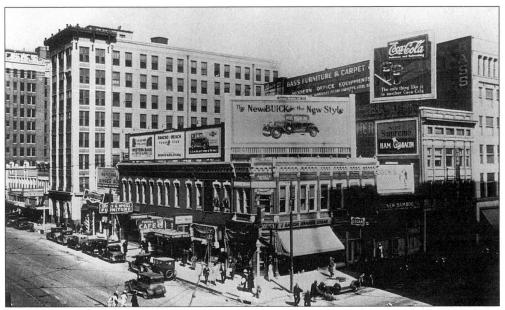

THE UNDERGROUND, C. 1925. This view of the Bassett Block at Main and Broadway shows the entrance to the underground Chinatown. Bill Skirvin would sit in his hotel lobby and watch the Chinese residents enter the alleys behind the Bassett Building and walk down the steps leading to their very private world.

It is rumored that once below ground, one could gain entrance through the "golden doors." (Griffith Archives.)

GOLD INDEED, C. 1925. During the construction of the Myriad Convention Center, workers began to unearth glassware, odd pieces of furniture, and scrap pieces of paper. This item was found among the rubble of the underground Chinatown and could possibly be connected to some fortune teller. The marks on the lower right translate to "10-3-character-ghost-bones." More simply translated, this means that someone wanted 13 members of a household eliminated! (Griffith Archives.)*

THE SOROSIS, C. 1925. The Sorosis formed around 1900 as a club for ladies interested in studying music, literature, drama, and art. Built sometime in the 20s at 1520 North Robinson, this red brick clubhouse had a ballroom, auditorium, private banquet halls, and offices for its members. The building now houses loft condos. (Griffith Archives.)

CENTRAL BUSINESS DISTRICT, C. 1925. The Frisco and Rock Island tracks divided the city east and west, while the Santa Fe (not shown) divided it north and south. This photo looks to the east from the garment district. Note the Petroleum Building with the oil derrick on its roof. (Griffith Archives.)

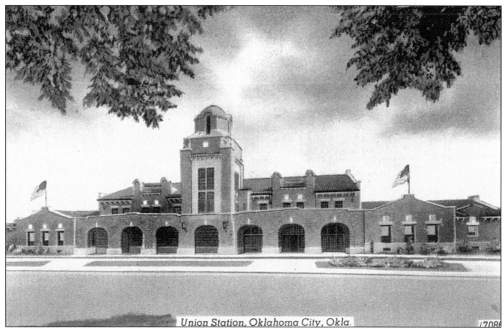

Union Station, Oklahoma City, Okla. 17086

UNION STATION, C. 1925. When the Rock Island and Frisco trackage was moved from the central business district to south of town, the Union Station was constructed at 300 West Seventh. It was built in the Spanish-colonial style and featured chandeliers in the 70 feet by 70 feet main waiting room. The station closed in the early 70s. (Griffith Archives.)

WHERE I SIT, C. 1925. This McArthur photo shows a view of Broadway looking to the north showing the Medical Arts Building. The reverse reads, "This is the building where I had some dental work done on the twelfth floor. In the northeast corner of the building you can see a little cross by the window where I sit, G.L." (Griffith Archives.)*

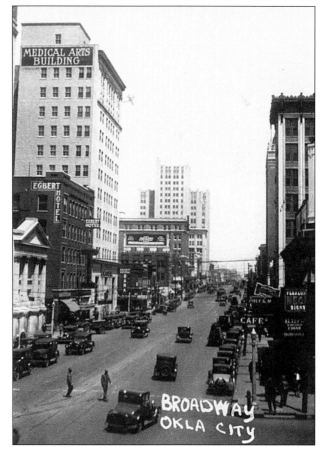

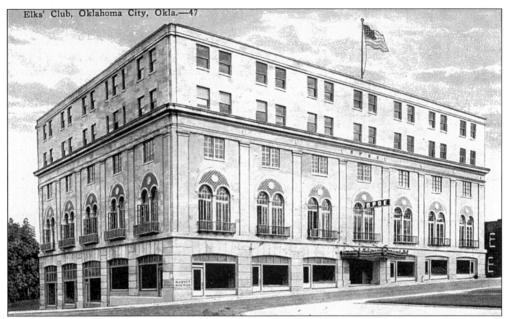

ELKS CLUB. The Benevolent and Protective Order of Elks began in Oklahoma City in February 1898. In 1926, they built their new home on the northwest corner of Third and Harvey. After a few years, the Elks moved out and the building became the home of the Oklahoma Natural Gas Company. (Griffith Archives.)

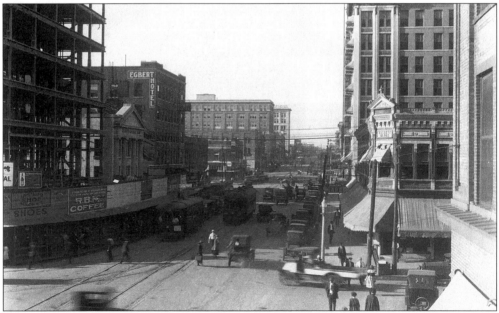

LIBERTY PLAN BUILDING, C. 1926. Construction on the new Liberty Plan Building is in full swing when this photo was taken. Looking north on Broadway from Main, the new building is next door to the Security National Bank and the Egbert Hotel. The telephone building is in the background, and the Bassett Block is on the right with the Insurance Building next door. Note the giant marquee advertising the Light and Power of OG & E. (Barney Hillerman Collection of the Archives and Manuscripts Division of OHS.)*

RODEO OF 1926. This group of Native Americans from the Kiowa Nation poses in this photograph taken for the April 22, 1926, rodeo as a part of the 1889ER Day celebrations. Two medicine men are standing on the steps of the Federal Courthouse and Post Office. Note the wedding band on the hand of the man on the left. (Griffith Archives.)*

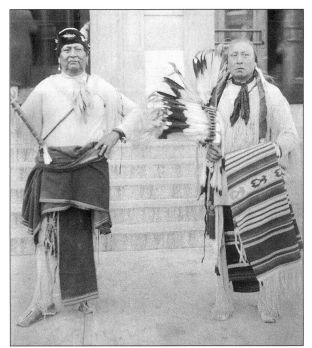

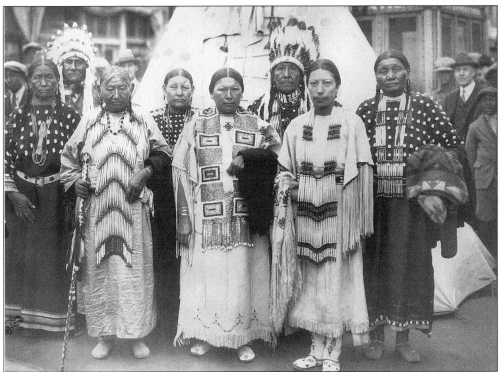

KIOWA TRIBE. A crowd gathers as members of the Kiowa Nation pose for a photograph. The Kiowa Tribe of Oklahoma came from Montana when they were driven out by the Sioux in the late 18th century. They settled in the area of present western Oklahoma and the Panhandle of north Texas, and west New Mexico. (Griffith Archives.)*

MID-CONTINENT LIFE INSURANCE CO. — OKLAHOMA CITY, OKLA. 4A-H1361

MID-CONTINENT LIFE, 1927. Contractors J.H. Frederickson and Company built this structure, which is 150 feet long by 70 feet wide and four stories high. Officially dedicated in May 1927, this building is located at 1400 Classen Drive and has a total floor space of 42,000 square feet. The exposed woodwork in the building is mahogany imported from the British Honduras. (Griffith Archives.)

SPRINGLAKE PARK, 1927. David J. Perry and Albert L. Clarkson with their wives, Henry Ione Overholser Perry and Blanch Rowland Clarkson, are pictured at Springlake Amusement Park in 1927. (Rowland A. Clarkson Collection, Greeneville, Tennessee.)*

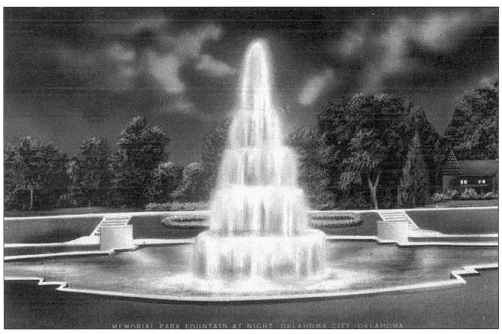

MEMORIAL PARK FOUNTAIN AT NIGHT, OKLAHOMA CITY, OKLAHOMA

WHERE'S THE DOUGH BOY? 1927.

When the lake was drained at Putnam Park the name was changed to Memorial Park, in remembrance of the men and women who served in World War I. The 20-foot fountain was built in 1927 at a cost of $3,500. The water was turned off in 1941, and it was not until 1977 when the Uptown Kiwania Club provided a portion of the funding that the fountain could be restored and once again made operational. The original plans called for a statue of a doughboy to grace the top of the fountain. (Griffith Archives.)

TOWER OF MEMORIES, 1928.

Dedicated to the members of the American Legion, a plaque on the tower reads, "Cornerstone laid November 11, 1928 by members of the American Legion Post 35." The tower was completed in 1929 and is located in Memorial Park Cemetery. Wiley Post is buried not far from the tower. (Griffith Archives.)

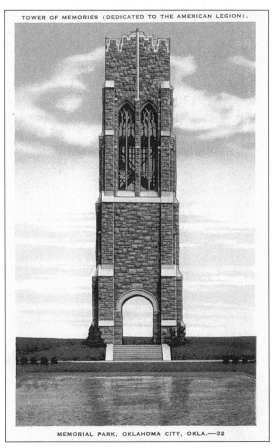

TOWER OF MEMORIES (DEDICATED TO THE AMERICAN LEGION),

MEMORIAL PARK, OKLAHOMA CITY, OKLA.—32

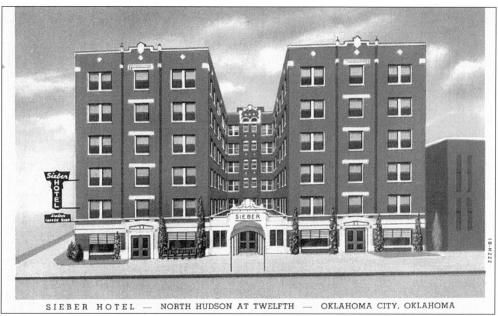

SIEBER HOTEL — NORTH HUDSON AT TWELFTH — OKLAHOMA CITY, OKLAHOMA

APARTMENT HOTEL, 1928. Completed in the summer of 1928 by Swiss immigrant and grocer Robert G. Sieber, the Sieber Hotel was one of the first apartment hotels to be built in the city. Located at Twelfth and Hudson, the structure cost about $250,000. It contained 65 single rooms, 6 one-bedroom apartments, and 9 efficiencies. The building stands empty today. (Griffith Archives.)

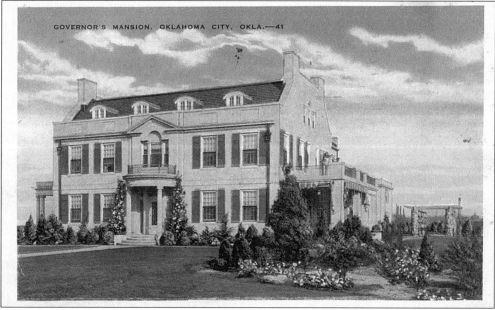

HOME FOR THE GOVERNOR, 1928. This 19-room home was constructed in the Dutch Colonial style at a cost of $75,000.00. Governor William J. Holloway was the first occupant, followed by the controversial William H. "Alfalfa Bill" Murray, who uprooted the lawn and plowed the earth with mules so that it might be planted with vegetables for needy Oklahomans. (Griffith Archives.)

126

THE GREAT DEPRESSION, 1929.
Oklahoma City residents suffered through
the great depression triggered by the stock
market crash of October, 1929. As far as the
city was concerned, effects of that dire
economic period would have been much
worse if it had not been for two things: the
discovery of oil in the Oklahoma City Field,
and the removal of the Rock Island and
Frisco tracks from the heart of the downtown
area. (Museum of the Ozarks History
Collection of the Archives and Manuscripts
Division of OHS.)*

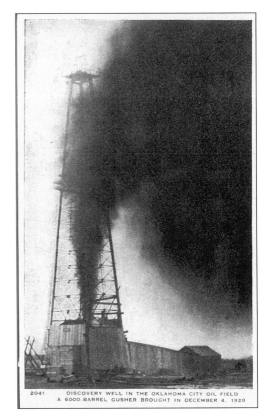

2041 DISCOVERY WELL IN THE OKLAHOMA CITY OIL FIELD
 A 6000-BARREL GUSHER BROUGHT IN DECEMBER 4, 1928

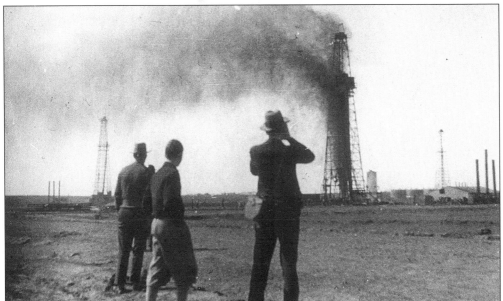

WILD MARY. On March 26, 1930, the most awe inspiring spectacle—and the only one most
people remember—was staged by the "Wild Mary Sudik," as it blew a film of oil as far south as
Norman. It produced 20,000 barrels of oil a day with about 200 million cubic feet of gas.
(Griffith Archives.)

GOOD-BYE KATY. These two Waterhouse photos show the last passenger train at the Rock Island depot on November 30, 1930. The depot was located behind the Skirvin Hotel. Note the oil derrick on the left. (Museum of the Ozarks History Collection of the Archives and Manuscripts Division of OHS.)*